The Artist & the Nude

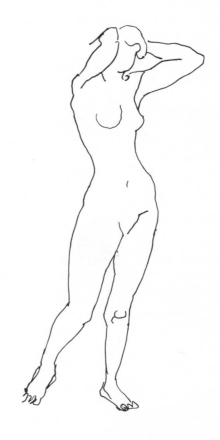

The Artist & the Nude

AN ANTHOLOGY OF DRAWINGS

EDITED BY MERVYN LEVY

Published by Barrie & Jenkins Ltd.,
in association with Corgi Books.

A National General Company

THE ARTIST AND THE NUDE

A CORGI BOOK 552 98345 4

Originally published in Great Britain
by Barrie & Rockliff (Barrie Books Ltd.)

PRINTING HISTORY
Barrie & Rockliff Edition published 1965
Corgi Edition published 1970

Copyright © 1965 by Barrie & Rockliff (Barrie Books Ltd.)

PRINTED IN GREAT BRITAIN BY
FLETCHER & SON LTD, NORWICH

Contents

Introduction

A PENCIL, a piece of chalk, a broken length of charcoal, a cheap pen; with such simple materials, artists have laid bare their souls. And never more so than when drawing the human figure. A drawing of the nude is a most revealing expression because it is at once the most private and the most personal. Often such drawings are made with no thought of public exhibition; they possess the intimacy of diary entries. They are secrets. Drawings of the nude provide the crucial clues and links essential for a complete understanding of an artist's work and personality. They comprise that aspect of his *oeuvre* most comparable with the notebooks and diaries of the writer. But they are even more revealing than these, since whereas an author will frequently refer to his notes, an artist's drawings of the nude, except in those cases where he makes preliminary studies for a project, are isolated statements to which he may never again refer. He may even forget their existence entirely. Often after an artist's death his studio effects reveal dusty portfolios which have lain hidden for years. It is from sources such as this that some of the most interesting sidelights on an artist's life and work suddenly emerge. From this point of unexpected discovery the secrets trickle out into the world; into galleries and sale-rooms and the pages of books.

Many of the figure drawings of the late Augustus John came to light in this way after his death; the remarkable study of a young woman (7) for instance. A drawing such as this throws a clear light on the essential John. Here is the draughtsman of superb accomplishment combining in the one startling image an elegance, a sensuality, and an exuberance which are the quintessence of the man. John is revealed in this solitary drawing as a dazzling virtuoso with a hankering after the graceful—here the tilt of the head. It is a strongly individualistic drawing. The model is posed with an abandon that shatters all the niceties of the conventional pose.

In the life class where the artist makes his first acquaintance with the nude, the model is invariably posed with caution. Poses are strictly asexual. "We'll have a standing pose this morning. Yes—that's all right. Let your left leg take the weight. That's it. Now—right hand on your hip, please. Fine. Just turn your head to the right and look out

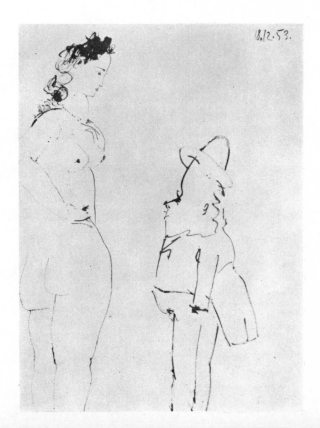

of the window. Splendid. Right now, we'll keep this pose for the whole day." Every morning during term time in some two hundred art schools throughout the country, these are the kind of instructions given to the model by the instructor setting a pose. The occasion is solemn and clinical, with the students hovering respectfully in the background. The typical art school pose is contrived and artificial, and descends in the form of a sterile convention from the solid classicism of the Renaissance. This convention is echoed wherever there is a classical emphasis; for instance, in Prud'hon's study for the figure of *Innocence* (5).

After a while the enterprising young artist of imagination and spirit will react strongly against the artificiality and lifelessness of the art school pose, and engage a model privately. Sometimes a group of students will hire a model. Or a girl friend may agree to pose. Or the young man will become friendly with a professional model. It is from this point onwards that the relationship between the artist and his nudes starts to become really interesting.

The artist can approach the problems of figure drawing from three directions. He can work in the life class, in his studio, or from his imagina-

tion. In the main drawings which make up the present volume spring from the two latter categories, although a few artists have used the art school throughout their working lives. Etty, even in maturity, frequently used the life schools of the Royal Academy; perhaps from modesty. In spite of the frequent voluptuousness of his subject matter he was, by all accounts, a man of some reticence and timidity in the presence of women. And Gaudier-Brzeska, out of poverty, used a little sketching class in Chelsea during those few years of work in London before he was killed in 1915 (11).

★

But first let me establish the terms of reference on which the present book is based. The title *The Artist and the Nude* could cover the whole of human history; man was painting and drawing the nude figure in his cave. This seemed to me too large and diffuse a subject, or anyway one that could hardly be dealt with adequately except in a series of lengthy volumes.

Where then to begin, and where to end? The answer it seemed would be to select a particularly

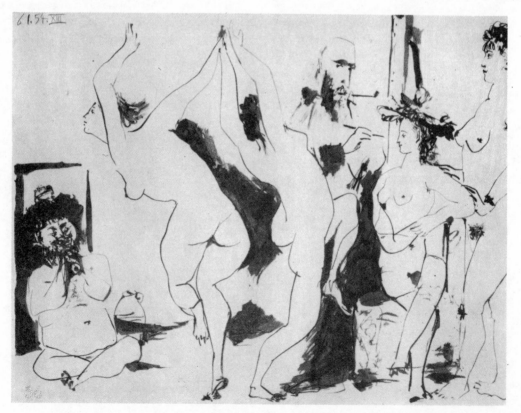

interesting period, and one with many changes, and use this as a microcosm of the whole. Human nature has changed so little in its essentials that one may reasonably suppose that a study of any human activity and endeavour in one period will reveal not only what is contemporary but what is perennial.

For example, the stylism of prehistoric figure drawings is echoed, however differently, in the stylistic treatment of cubist figure drawing (43) or in the unique and personal stylism of a painter such as Modigliani (38). These three art forms—one social (magical), one objectively intellectual and one subjectively personal—are easily comparable because they each seek to symbolise an idea. Though their objectives are different the mental mechanics from which they spring are the same.

Again, the line of the Greek draughtsman searching for a formula that would match the intense naturalism of classical sculpture in drawings on the curved surfaces of ceramics, has its counterpart in certain drawings by Picasso (62) Matisse (76) and Derain (102). In each of these three drawings the artist, though unhindered by the technical limitations of the pottery painter, has imposed on himself a comparable limitation. But this basic comparison does of course admit of differences. Matisse, for example, has submitted to the demands of a purely decorative approach. Picasso, in his exquisitely melting drawing of two nudes (41) has made more tender the modified naturalism of the classic draughtsman—from whom he learnt so much—whereas Derain and Matisse have preserved the essential tension and brittleness of the classic line.

The figure drawings of Modigliani, Picasso, Matisse and Derain, to which I have referred, can be seen as a microcosm of the universal, since stylism and naturalism are constants in the history of art. However disparate in terms of intention or culture, however far apart in time, each form of stylism or of naturalism will illuminate not only its immediate surroundings but also areas quite remote.

The period I have chosen to illustrate in this book is that of the eighteenth century to the present. This period saw the development of the spirit of enlightened individualism which prevails in western culture today. Of humanism—a term

in frequent misuse—I will not say too much. Few artists are rampant humanists, nor is western society particularly notable for its humanism—for its rampaging individualism, yes. In the last two centuries an ever increasing emphasis has been placed on the significance of the individual, and, except in the totalitarian countries, on his rights and privileges. It is, I think, interesting to see how, in such a period, the individual artist is revealed in the mirror of his figure drawing—a mirror which will of course catch other reflections in its surface. In these two centuries, more than at any other time in the history of western art, the draughtsmen of Europe and America have been free to reveal themselves, and incidentally something of their social environment, with no more serious objectives in mind than to draw their models, mistresses, or wives in some striking and absorbing pose.

A drawing of the nude is fundamentally a free gesture, but it is also a revelation of something more extensive than the artist's immediate concern. Egon Schiele (25) epitomises the feverish obsession with eroticism (is the nature of decadence the separation of sex from love?) which was typical of one aspect of the lush crumbling of the Hapsburg Empire. The communist painter Renato Guttuso's bitter portrayal of a nude Algerian woman (19) and the drawings of Georg Grosz (18) are clearly social and political statements. In the main, however, the drawings which appear in this book are uncommitted, isolated observations, even though they reflect, often unconsciously, society and social conditions.

Even the artists of the French court who appear here, such as Boucher (60) or Watteau (88) were free in the sense that the amoral is a form of freedom. In an age such as our own, when the artist is unhindered by any form of discretion, and when the objective of art—especially of the literary and dramatic arts—is to lay bare the most intimate aspects of human conduct and personality, the relatively restrained abandon of French court art gives way to the greater degree of disclosure in drawings such as those of the American artist Charles Cajori (33) or the Goan painter Francis Souza (100 lower). These, though very different in approach and style, are both essentially "free" drawings of the mid-twentieth century.

Pornography is another matter. Throughout the ages artists have produced straight pornography for specific uses—personal or public—such as the paintings at Pompeii, or the so-called "obscene drawings" of Henry Fuseli. By comparison with these, Cajori's and Souza's conceptions are in no sense pornographic, but even so they are freely admissible today only because our social climate is broad-minded enough to accept them, without imposing moral reservations upon the artist's right to deal frankly with any subject that compels his imagination or intellect.

These two remarkable drawings differ of course in a number of respects. The Cajori nude is a "studio" study, a statement of fact. [Compare it with another of Schiele's drawings (68 top).] On the other hand the Souza nude is an imaginative drawing. Francis Souza, an artist passionately concerned with the nature of man, has often dealt with the theme of lust. This is frequently expressed by the juxtaposition of two simple images; the beautiful and voluptuous female, and the

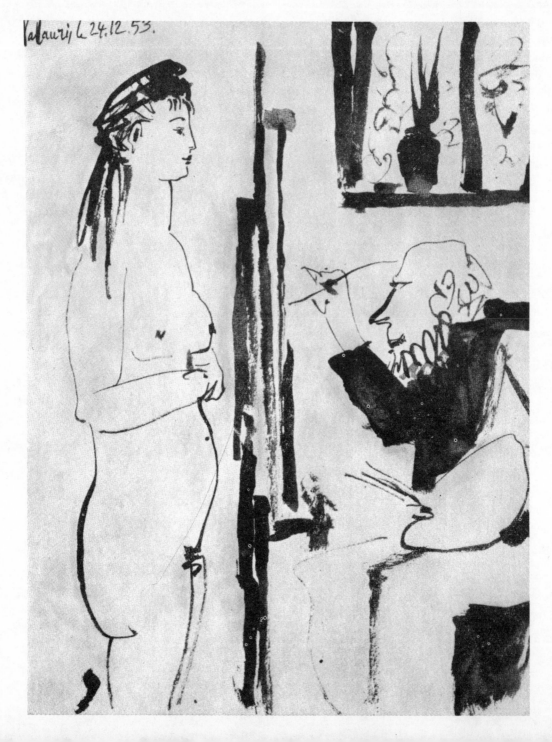

hideous male furtively grovelling and sidling towards the object of his desires. Usually in such pictures the woman is represented as indifferent to the advances of the man, or, as here, even unaware of them. But this is not a "moral" statement; it simply illustrates in a suitably imaginative way an aspect of human personality.

★

In selecting the drawings used in this book I have included some of partially clothed figures. The reason is quite simple; garments often enhance and intensify nudity. Scanty clothing or decolletée give the naked figure an added dimension of voluptuousness, or even satire. Perhaps especially satire. Consider how the Italian artist Pirondello uses clothing to impart a cutting edge to satire (90). Rowlandson often did the same thing. By concealing certain areas or forms the artist renders them the more naked. This has always been recognised, whether in painting or sculpture; the Greeks were supreme at it. Another aspect of the art of disclosure by concealment is the masking of one part of the body by another.

French court painters and draughtsmen were masters of this particular convention (60).

A modern instance is the cult of the semi-draped pin-up photograph which has had a profound influence upon the young pop artists of Britain and America. They have adapted the convention as a means of social comment. Peter Blake's *Pin-up Girl* (12) and Allen Jones' two drawings, *Figure Study* and *Variation on Today* (6) illustrate the way in which young artists have responded to a popular convention concocted in the first instance and quite cynically for mass consumption at the lowest levels of society. The pin-up photograph is crude and tasteless, its aesthetic content is nil. But the sensitivity of Blake and Jones has transformed this superficial pornographic convention not only into a social statement, but also into true works of art. There is even dignity and grace in their variations on this theme.

These then are my basic terms of reference; nudes and partially clothed nudes by artists from the time of Hogarth to the age of the pop painter

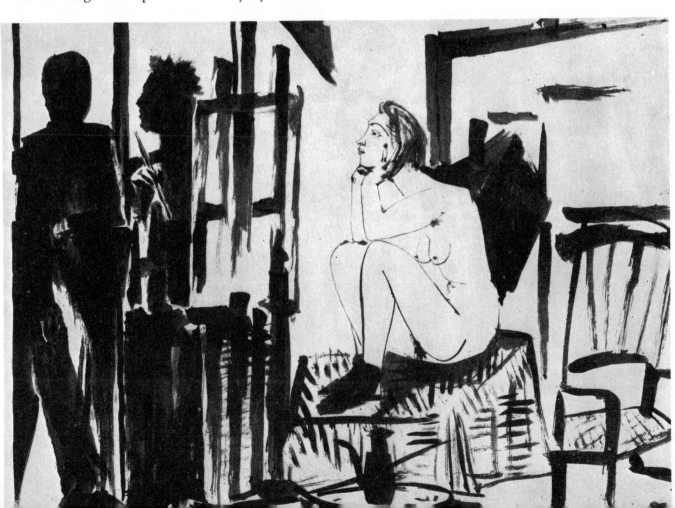

The great majority of the works here are clearly "drawings" in the sense that they are primarily linear and have been rendered in the usual drawing materials such as pen, chalk, pencil or charcoal. Even so, artists such as Degas or Steinlen often use the line of pastel or charcoal to create effects which, being more diffuse, are closer to painting than to drawing in the purely linear sense. I have included such drawings as these—and indeed a water-colour drawing by Georges Rouault (52) and two monotypes by Degas (31 and 63)—because the initial attack has been in line. Irrespective of the flat areas of tone the artist has added as a support for the initial framework, the conception is, fundamentally and structurally, a linear one.

<p style="text-align:center">★</p>

Two factors condition the kind of drawing an artist produces; his intentions, and his materials. The choice of a medium is every bit as important as the choice of a subject. If the medium is not sympathetic to the kind of drawing which the artist hopes to produce, he will certainly fail. It is no use scratching away with an H grade pencil if you have responded warmly and tenderly to a subject such as Steinlen's *Nu* (64). Clearly this calls for a soft, tender, yielding medium, and quite rightly Steinlen chose charcoal. A difficult medium to control, in the hands of a master it lends itself to the most beautiful and subtle effects. It can be rubbed—as here—to produce passages of exquisite delicacy, or used with a sharp though always delicate line, to pick out accents that need emphasising. Used on a textured or coloured paper, its attractions are intensified. Vine charcoal, obtainable in stick form and in various degrees of thickness, is a medium of the utmost sympathy. It breaks easily and the artist usually works with a broken piece, perhaps no more than a couple of inches in length. Artists can obtain metal charcoal-holders if they wish, but most prefer the feel of the naked medium, and enjoy the intimate contact with the living material from which the image grows. This sense of identification with a medium such as charcoal or chalk is very important. It is an integral part of the creative act.

A more commonly used and equally sympa-

thetic medium is chalk. Generally known as conté crayon—or conté chalk (*Conté á Paris*)—it is made in short sticks and in red (sanguine), black or white. Like charcoal, the sticks are easily broken and artists often work with tiny pieces. Conté crayons are square in section so that the draughtsman can draw lines with the edge of the chalk, or apply broad, even passages of tone with the flat side of the stick. The medium rubs beautifully—with the finger—to produce exquisitely modulated passages of tone, the scale ranging from rich depths to the merest breath of tone. Derain (3) admirably illustrates the qualities of the medium in the hands of a master. Red chalk, or sanguine as it is also known, is not of course red in the crude sense of the term; it is a muted, bricky, terra-cotta colour, and if it has a disadvantage, it is simply the very beauty of the medium itself. In the hands of a minor artist it can be used slickly to produce superficially attractive effects which at first sight mask the fundamental shortcomings of the drawing. But in the hands of a master it is the medium of the gods. Black conté also is something more than just black; it has a rich velvety substance and its range of qualities is demonstrated here in the drawing by Georges Seurat (17).

This artist, whose short working life was devoted to the cause of *Pointillism*, died in 1891 at the age of thirty-two and probably made this drawing in 1882 while sharing a studio with his friend Aman Jean with whom he entered the *Ecole des Beaux Arts* in 1878. After a year of military service he returned to this studio and resumed his studies, exploring in particular the play of light and shade on the forms of the naked figures. He used charcoal, crayon and chalk during the period of these studies in chiaroscuro, which reveal both the origins of his personal concept of Impressionism (the scientific application of the colours of *Pointillism*) and the influence upon him of such masters of the classical manner as Raphael, Poussin and Ingres. The drawing here reproduced is both classical *and* impressionistic in conception. But it demanded a medium—chalk—used in a way which would hardly have satisfied the needs of Ingres, who was most fulfilled as a draughtsman when using the point, whether of a pen, a pencil or of chalk (which can be sharpened to a point in its pencil form).

In his drawing of the nude Seurat creates form by means of tone, by the opposition of passages of light and dark and skilfully modulated areas between; we are not conscious of line, of linear contours. Another such a draughtsman was Sickert (26), constructing the form from within, rather than working inwards from the contour. Most tonal masters work from the centre outwards, rather than from the peripheries inwards.

By contrast, the foundation of the art of Ingres is line. To Delacroix, whose work Ingres disliked, he once remarked: "Line is probity itself." (It was also Ingres who wrote: "Drawing is the probity of art.")

The basis of the art of the Austrian master Egon Schiele is also the contour, yet his is very different from that of Ingres. Both drew in line, Ingres in the cold classical line, Schiele in the hot expressionistic line. Both draughtsmen required a medium which would respond to their own requirements, and both found it, *par excellence*, in the point of the pencil and of the chalk. Ingres demanded a medium that would yield little, that would contain and control any excess of sensuous energy, any overflow of emotion. A medium that would impose an added discipline upon a classical disciplinarian who, for all the superficial sensuousness of his conceptions, would not yield an inch, aesthetically, to the expression of sensuality. Ingres is reputed to have been something of a voluptuary, but this natural sensuality is carefully contained by the use of a relatively hard pencil (28). Here there is none of the melting and voluptuous flow which distinguishes the erotic line of Schiele (68) who used a yielding chalk, charcoal, or soft pencil. For Schiele, as for Ingres, drawing was the probity of art, and line was the spirit of probity. But a comparison of the two draughtsmen and their use of similar media reveals the immense gulf which separates them, not only as individuals, but as spokesmen of their time.

In the early years of the nineteenth century the conservative forces of the French Academy were powerfully aligned against the Romantic and the Realist painters. It was a form of reaction which harked back to the classicism of David. Ingres, the austere neo-classicist, was a key figure in the conservative fight against the new movements. He was passionately against the voluptuousness of the romantics as exemplified in such drawings as Theodore Gericault's *Le Baiser* (24). He succeeded in keeping Delacroix out of the Academy until 1857 which points to this hatred of the romantic view. "To wish to dispense with the study of the ancients and the classics is either folly or laziness," he said. So his line is cold, clinical, lacking in empathy.

There are of course many draughtsmen who can use pure line with passion. Rodin leaps to mind (21), and a good minor master such as Kolbe (92). And even smaller artists such as Horace Brodzky, friend and biographer of Henri Gaudier-Brzeska, frequently demonstrate how warm and responsive to the mood of the living flesh pure line can be. Brodzky is a little master of the pen, and his drawing of a reclining figure (105) beautifully illustrates through the wiry line of nib and indian ink a real sensation of luxurious respose. It does not follow therefore that only the classicist uses line, or at least the relatively harsh line of the pen or the hard grade pencil. The essence of the distinction between the line of the avowed classicist and the line of the romantic or the humanist (and one must frequently distinguish: Delacroix for instance is a romantic, and Rodin a humanist) is contained either in the sense of tactility, of empathy, of *life* with which the line itself is charged —like a sort of electric current pulsing and throbbing through the contours—or with the negation or absence of these qualities. In this respect you have only to compare the line of Ingres with that of Rodin. Yet curiously, both artists use a relatively hard point, whether of pen, pencil or chalk. But how much a matter of feeling all this is becomes clear if one compares not only the way in which the classicist and the romantic, or humanist use the point, but the way in which, on occasion, they use such soft and yielding mediums as chalk. Contrast Gericault's use of chalk [*Le Baiser* (24) is drawn in sepia and black chalk], and Prud'hon's use of the same medium (5). To continue with this comparison of feeling and anti-feeling, consider Rodin's early pen and ink study of *Aphrodite and Adonis* (21). Here is a classical subject conceived and expressed with feeling. And by feeling I mean sensuous feeling.

It is clear, therefore, that although the draughtsman will usually select a medium suitable to the

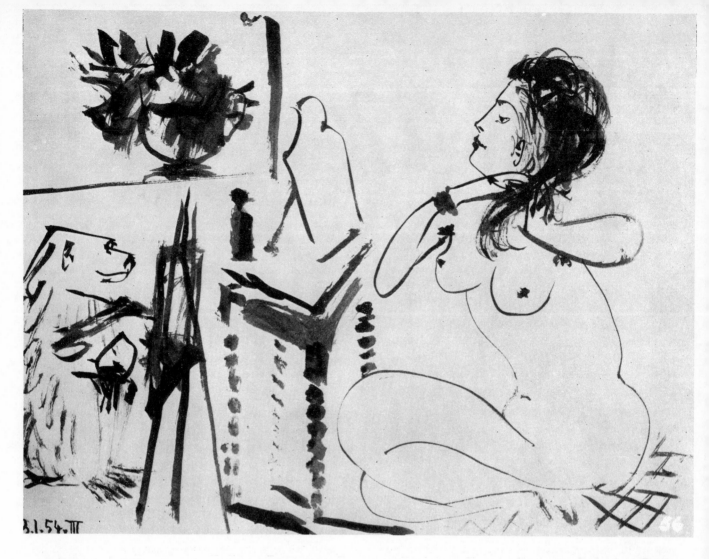

exposition of his particular objectives, whether these be emotional (involved) or intellectual (detached), he will from time to time seek to bend less malleable or appropriate media to his ends. Sometimes this approach will succeed, at other times it will fail. Prud'hon failed in his endeavour to compel the natural richness and sensuousness of chalk to fit a rigid, frigid framework. After all, drawing is a form of making love; drawing the nude especially so. The artist clasps the subject in an embrace, even though that subject may in itself be repellent. Such are the identifications of artists like Lautrec, Rouault or Pascin, with the image of a prostitute. Always where there is love-making there is warmth and feeling, and often, in draw-ings, these sensations are sharply communicated to the spectator, not least by virtue of the medium with which the draughtsman works; the softness of chalk or charcoal, or simply the pen-line that lives and breathes and undulates on the paper. It is so with Rodin, and with Gericault, and with

modern romantic-expressionist humanists like Schiele. Or Picasso who, even when his line is transmuted into acid satire, as in the series of painter and model drawings which thread their way through this introductory note, still makes love, and passionately, in the very act of drawing. So perhaps we can say that if the artist's feeling—if his "love"—is intense enough, it will transcend even the material limitations of "hard" media such as pen and ink, or hard pencil.

A good example of this is the work of another contemporary Indian artist, Avinash Chandra (46). He, and Francis Souza have kept burning the essential flame of the Indian erotic idiom in drawings executed in the context of a modern western environment. Both artists are still relatively young men; both have contributed through their figure draughtsmanship alone a magnificent flavour of the tumultuous eroticism that is their natural heritage. This applies particularly to the drawings of Chandra, whose work is in the direct line of

descent from the sculpture which adorns the great temples of Khujaraho and Konarak. The remarkable thing is that so intense an afterglow of erotic emotion is conveyed through the use of such a hard medium as the line of a pen.

★

One of the most interesting considerations which faces the student of figure drawing is the very clear difference between the drawings of sculptors and those of painters. This is perhaps inevitable, since the sculptor is primarily concerned with the representation of form; I mean pure, physical form (however that is eventually conceptualised: even in purely abstract terms), whereas the painter is usually more concerned with the representation of an idea, of a mental state, which has already begun to shape and condition his conception of form before he sets brush to canvas. For the painter, form is subservient to the idea. Not so for the sculptor, who is always, and inevitably, drawing towards the round. He thinks in the round. The painter thinks in a different time-scale. For him the subject is extensible in a number of directions. The painter is a "literary" thinker; he is concerned with "story", a mental attitude which presupposes a time-scale. Looking at Manet's study for the figure of Olympia (58) one realises that here is an element detached from an entirety. It has form of course, only here the attitude to form is incidental to the larger context (the literary story) into which this detached element is to be locked. It is not a totality. But a drawing by Moore (81) or Butler (36), or Archipenko (93) is on the other hand a totality of form (and subject) in itself. Here are drawings which will lead to, or which may even have grown out of, solitary sculptural conceptions. In this sense the figure drawings of sculptors are purer, more certain in direction, more single-minded of purpose than the drawings of painters. They are crisper, less diffuse, less muddled by congestions of thought, less weighted down with ideas, less involved with the personality of the subject than the figure drawings of painters.

Oddly enough this point can be best illustrated by comparing the drawings of two sculptors; Epstein (35) and Henry Moore (72). Epstein more

than any other sculptor of his time thought like a painter. His ideas were literary rather than formal, in the sense that "form" is the primary concern of the true sculptor. His drawings of the nude are always "story" drawings, drawings of particular women. Epstein is a curious case since he was at heart, I believe, a painter rather than a sculptor, and would I think have expressed his objectives far better in the end if he had practised painting. For he drew like a painter, involving himself with the personality of his subjects so that we feel the impact of their individual presence in a way that could never apply to the impersonal nudes of Henry Moore, or to those of Gaudier-Brzeska (66) or Greco (84) or Despiau (39), or indeed any of the pure sculptors. One can quite easily compare an Epstein drawing of the nude with a Sickert (26), for instance. They are both literary, storytelling draughtsmen. And herein lies the crux of the difference between the figure drawings of painters and those of sculptors. The one is concerned with the impersonal, timeless exploration of form; the other with involvement in the temporal personality of the subject. Epstein fails as a sculptor because he did not (could not?—would not?) think as a sculptor should. His drawings make this clear. They are superb, painterly representations of the nude; of particular nudes.

Moore's perennial search, on the other hand, is for the archetypal mother-image; the monolithic rock-woman, timeless, placeless, faceless. A sort of Lilith among the forms of sculpture. Less obviously so, Reg Butler seeks a comparable universal woman image (36), and following the same line of detached, impersonal thinking, Gaudier-Brzeska explored form the better to expound his view of the facets, planes and geometry of the body that stemmed from his interest in Cubism (43). To simplify form in this way—or even to recreate it—it was first necessary to understand it utterly as a purely anatomical matter. Even those drawings of Gaudier's which are executed in pure line (11) are always restlessly feeling out, nosing through the subtleties and complexities of anatomical identity. If one compares a relatively straight drawing with one of his cubist studies one is instantly aware that in both these drawings the primary concern of the artist is with form. Not in any sense with the personality of the

model. The first of these two drawings aims at a pure appraisal—but with immense subtlety—of the anatomical identity of the figure. The second study is an attempt to recreate the intricacies of anatomical form in terms of an arbitrary geometric simplification. But the result is still a concern with form. With form recreated, remodelled, restyled, in an idiom that in 1912, or thereabouts, was little known or understood in this country. Alas, Henri Gaudier-Brzeska was killed in 1915 at the tender age of twenty-three, and his brilliant drawings can only hint at the size and scope of his largely unrealised objectives as a sculptor-draughtsman of tremendous promise. Even so his achievements are considerable. He is one of those rare sculptors capable of reconciling the idea and the form.

In a recent conversation I had with him, Henry Moore made it clear that his ideas always grow out of the actions of working. In other words, work produces ideas, not ideas work. This he pointed out is the way in which sculptors "think", as opposed to the method adopted by painters. Clearly this is how Gaudier thought, and worked. It is the basis of the reconciliation of the idea and the form which always distinguishes the art of the great sculptor. He works from the form to the idea, so that there is a built-in rapport from

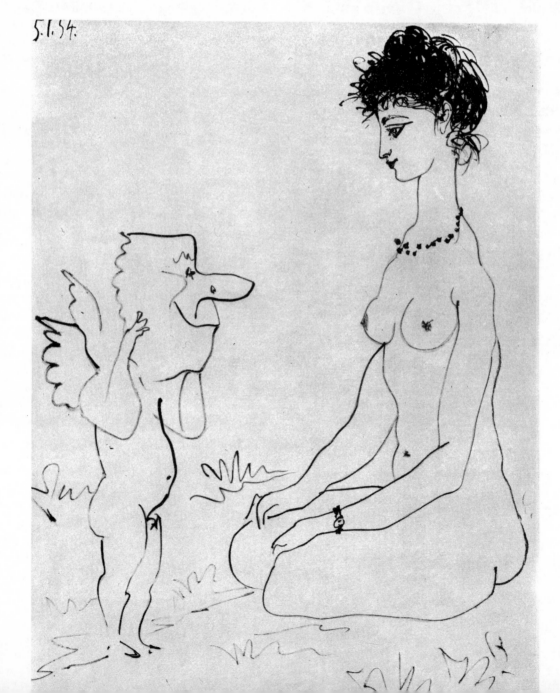

5.1.54.

the outset. To start from the idea is to drag form along behind you, and this is the method of the painter.

Rodin exemplifies the principle in a different way. Whereas Gaudier was absorbed in the problem of creating and recreating form, and Moore and Butler in the problem of universalising form, Rodin was concerned wholly with the problem of energising form; with the problem of translating energy, action, movement, into form. But always of course working from the living form to the idea of energy. As is well known, Rodin often drew from moving models. The essence of a Rodin drawing is form in action, pulsating with the rhythms and energies of the life-force (56), and made apparent, and tactile, because the sculptor's eye has been trained to read out of the subject he is drawing the most subtle and devious complexities of form. Once acquired and digested, this knowledge is understood and applied thereafter intuitively, so that it never comes between the feeling, and the expression of feeling. This is the secret of living draughtsmanship as opposed to the mere sterile rendering of academic knowledge. The one is implicit, the other explicit. In the main the sculptor looks at form with an explorer's eye, and his objectives—whether the search for geometric or universal forms or the desire to capture in line the force of forms in action that is life itself—are non-literary and non-story telling. Though Rodin might appear to be an exception in this respect, even he is seeking a universal rather than a personal vitality. For instance his sculptural representations of human love such as *The Kiss*, or *The Eternal Idol*, are portrayals of the energy and vitality of all such human passion. They are not portrayals of any particular encounter.

The painter sees less; or rather he sees other things. Look at a Marquet drawing of the nude (78 top) or a Kokoscha (79) or a Dufy (49). These are drawings of personality. Edited, limited, modified it is true; but drawings of personality nonetheless. They exist in a particular time-scale of human activities, events and characters. Not so in the main the uninvolved, detached drawings of sculptors. Perhaps this is the reason why the sculptor-model relationship is essentially different from the painter-model relationship. I mean in personal terms. Sculptors seem less inclined to enter into romantic liaisons with their models. The traditional bohemian artist-model-mistress relationship seems to be essentially the province of the painter, simply because he tends to involve himself with personality far more than does the sculptor.

As the sculptor is seeking a universal rather than a limited personal image, he is by the very nature of things always much closer than the painter to the impersonal character of primitive art. Henry Moore warmly acknowledges his debt to primitive Mexican sculpture. Gaudier-Breszka was profoundly influenced by the forms of African, Polynesian and Egyptian sculpture. Modigliani was indebted to African art in his sculpture. Even Marini and Butler cut back beyond personality to images which have their roots in primitive forms. They are all sculptors of the archetypal.

All this is clearly expressed in the sculptors' drawings of the nude which—in the main—are concerned with archetypal-form (the monolithic image), while those of painters are involved in the pursuit of an emotive, personal image in which the idea, often a romantic idea, precedes the creation of the form. The painter works from the idea to the form, the sculptor from the form to the idea. This view is splendidly confirmed by Maillol's *Nu accroupi* (22) the drawing for the marble of that name.

Among painters, and as though to prove the exception to the rule, one of the rare artists to work from the form to the idea is the Belgian, Constant Permeke. Primarily concerned with the depiction of proletarian prototype figures—labourers, seamen, farm workers—a drawing of the nude such as the one here reproduced (82) is clearly a universal form image. It has no particular identity or personality. It might easily have been the drawing of a sculptor.

One other type of draughtsman is preoccupied with the problem of form; of anatomical form. This is the 'academic' artist pure and simple. I use the term academic to denote the exercise of a slavish and sterile observance of some officially approved scheme of principles, such as the scientific tenets of perspective or the empty pursuit of anatomy for its own sake. It is upon such schemata that the aspirations (and the limitations) of the

academies of art are founded. One should perhaps note *en passant* that the rules of the game have now changed somewhat so far as the "academic" training of the art student is concerned. Anatomy and perspective have largely been superseded by the schemata of "basic design". Either way the outcome is equally sterile. The principles of art should never obtrude. A few artists—the best (and there are few enough of these)—will of course make a constructive and, eventually, creative use of academic schemata, of factual knowledge. The essence of Picasso's genius is that he had completely absorbed the academic foundations of drawing (and painting) at a very early age.[1] What follows is pure creativity. Thereafter academic data are modified, extended, recreated, and distorted, to meet the ever changing requirements of the most restless and profoundly inventive genius of the twentieth century. The essence of creative drawing is modification, adaption, omission (what is drawing but the art of leaving out?); a creative reorientation of the substance of academic principles and data. The extent of this practise will of course vary with the artist. Derain (40), Forain (71), and de la Fresnaye (112) are masters of omission. Nadelman (98), Klee (48) and William Scott (84) are masters of recreation and invention. It is also clear that these masters, and others, such as Dix (94), Lachaise (110), Klimt (65) and Bellmer (43), can all draw "academically", yet each has adapted the academic system to their own specific and larger ends. In each case the "idea", that which the artist wished to say, and passionately (the academic method is passionless), has been permitted to flow and express itself freely because the draughtsmen have been prepared to modify the pressure of academic schemata in the larger interests of the story they wish to tell. The last four artists give us widely different views of the female nude, each represented with great individuality yet clearly bound by a basic, yet modified understanding of academic anatomy. All are examples of the way in which the draughtsman can adapt the academic framework to his own creative ends. The tenderness of Klimt's pregnant girl, the

[1] Picasso is himself recorded as saying: "At twelve I was drawing like Raphael." *Picasso*: Antonina Vallentin (Cassell, 1963), p. 5.

mammary madness of Lachaise, the pathos of Dix's "Girl in a Petticoat", and the haunting introspection and fantasy of Bellmer's dreamlike "Woman on a Sofa" all spring from the same basis of academic knowledge, but knowledge held subservient to the idea.

The bigger the artist the greater his control and use of academic knowledge. Other, and of course lesser artists, "academic" artists in the bad sense, always remain enslaved by the sterile entanglements of academic precept and method. In them the dead hand of the academies of art stifles the free flow of creativity in the weeds of criteria. This is the academic death which produces the corpse drawing of Adolf Menzel (29) and Joshua Reynolds (111). For though both these artists made their own small contribution in the field of painting (Reynolds to portraiture, Menzel to the study of objects in light—an objective, by the way, traceable to the influence of Constable) in their representation of the female nude, they reveal an absence of all those sensual and tactile qualities we normally associate with an empathetic drawing of the female body by artists such as Degas (8) or Pascin (13), Renoir (1) or Bonnard (55). The Menzel and the Reynolds drawings are the academic death *par excellence* and, in their way, splendid examples of how academic criteria can rob a drawing of all emotion and all life. This is the representation of dead form minus living idea. It is drawing for no reason, and to no end. Both artists have looked upon the nude—upon the living flesh and bone of the human body—as upon so much stone. The academic manner—in this sense at least—is a form of second-rate antique drawing with the model playing the part of the cast. Negative academism of this sort must not of course be confused with classicism, which is, at its best (as in Ingres) a perfectly legitimate method of employing the principles of the academic system to a positive end. The essence of the academic method as a negative activity is the self-conscious pursuit of form, uncontained by any imaginative idea. Reynolds and Menzel are here acting in this sense.

There are other types of academic artist using a tight system of conventional observation who nevertheless, and because of the intensity and clarity of a basic idea, transcend the limits which

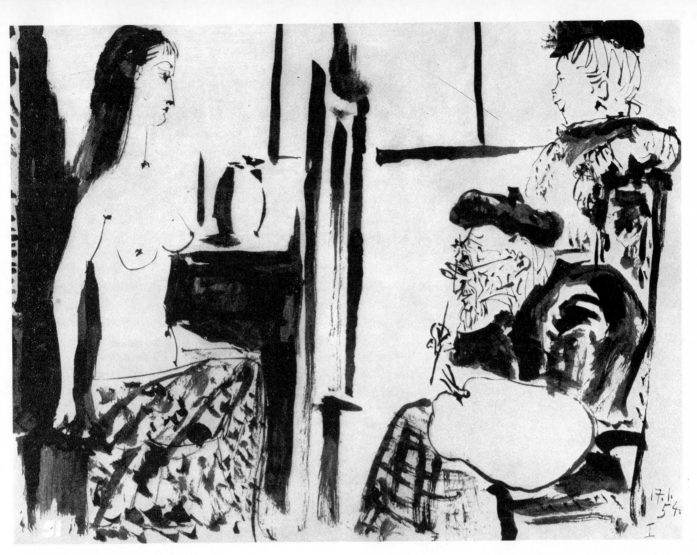

the negative academic approach inevitably imposes. Such masters as Hogarth (50-1), Constable (2), Etty (37), Stanley Spencer (83) and Cézanne (45) are all positive and creative masters of the academic method. Each of these artists has drawn the nude as part of a larger and developing pattern of artistic activity. Their drawings reproduced here are exploratory stepping stones towards this end. Hogarth explores form the better to express his own peculiar view of satirical morality. In his ultimate art—the engravings especially—one is conscious of the way in which anatomical emphasis is employed to intensify the artist's objectives. And compare Constable's standing male nude (2)—drawn by the way from the figure of an ex-guardsman who had fought at Waterloo and often posed in the life-class at the Royal Academy Schools—with Reynolds' stilted and lifeless female. The essence of Constable's art is life; vitality, energy, movement, activity. All these qualities are present in this superbly vital

and exquisitely graceful drawing. The muscularity is implicit rather than obvious; the foreshortening of the bent right leg is unselfconscious, taken in its stride: the rhythms and movements, the flow and energy of the man's body (and personality) are subtly implied rather than flung at one's head. It is a figure drawing of immense accomplishment and control, perhaps one of the finest and most brilliantly executed examples of a drawing of the male nude to come from the hand of any European draughtsman. Better, and greater it seems to me than those grinding, anatomically overloaded studies of the Renaissance masters. Its greatness lies in its selectivity and restraint. And this from the master of landscape! But then one must remember that even the merest flicker of a figure wandering through the Constable countryside is a profound summary of the detailed forms and actions of the human figure. And Etty, that luminary of the gently erotic, how well he controls and bends academic knowledge to his own

tenderly voluptuous ends (37). His vision of breasts and buttocks, of curvilinear grace, is always a song in praise of the beauty of woman, of the flesh and form he adored but by all accounts never tasted. His view of the nude is always that of an act of homage; of choice fruit looked at and adored but never plucked. All Etty's nudes are endowed with this sense of the ideal; of an illusion that was never shattered. For him a woman remains always beautiful because she is never known. And indeed in this sense knowledge is the corrupter of dreams. One has only to compare the nudes of Etty with the world-weary view of Pascin, or Lautrec.

Two other academic drawings are notable here for the light they throw upon the workings of artistic personality and achievement. The early life drawing of Stanley Spencer (83) displays the passion for detail, for the crisp, clean rendering of minutiae which was later to mark the character and form of this artist's great imaginative works. And Paul Cézanne's astonishingly felicitous exploration of anatomical form (45) drawn between 1862-8, when the painter was in his twenties, is an intriguing portent of that analysis of structure and form which was to become the increasing preoccupation of the artist and to lead him in his last works to the very threshold of geometric cubism. This remarkable drawing (rendered in charcoal, a most difficult medium to use with this degree of clarity) serves one other vital purpose: it dispels once and for all the nonsensical idea that Cézanne's later work is what it is because he could not draw properly. This drawing is in itself an eloquent and shattering answer to such a libel.

*

One curious feature of the relationship between the artist and the nude is the relatively conspicuous absence of any real interest in the representation of the male nude for its own sake. Traditionally of course artists, and particularly art students, have always drawn from the male body as a working supplement to the study of anatomy. Obviously it is far easier to study superficial anatomy—bone and muscle as they affect surface appearances—by reference to the male rather than the female nude. Look at a Schiele nude (68), or again at Cézanne's

study. The tradition originates with the anatomical studies of the Renaissance masters, notably Michelangelo, and later, say Tintoretto. But artists have usually shown a revulsion against the expression of any personal emotion towards the male body. It is never depicted with passion, or love. Sometimes with compassion of course, and for specific reasons, as in many of the drawings of Rembrandt —but no other display of emotion seems permissible in this connection. The overwhelming emotive attention of artists has always been concentrated on the female form. Not even the handful of women artists of distinction have paid the least (noticeable) attention to the male nude. It does of course frequently figure as an element in classical compositions, in certain erotic configurations, and sometimes it makes an appearance as in Picasso's devastating and brutal picture of a rape (30), or as a flashpoint for Jackson Pollock's conversion of anatomy into pure energy (23), a curious portent of abstract-expressionism. The answer must be that no male artists of homosexual inclination have felt disposed to portray, with emotion, the objects of their love, or the acts of their love (there are of course numerous drawings—and paintings—of lesbian activities).

*

I have already noted that the artist works from the nude either in the life-class, or "the studio". Of the art school and the life-class there is little to add to what I have already said. The atmosphere of such places is fundamentally impersonal and academic. The art school is a place for study; somewhere dignified and relatively inexpensive (a scholarship student of course, in this country at least, pays nothing for the services and tuition of the art school) where the young artist can learn the rudiments of his art. The life-class is a focal point in the pattern of his early training. Indeed an artist's entire future may depend upon the seriousness with which he undertakes these early and vital studies in the mechanics of drawing. Sometimes the effect of the life-class will be still felt in the work of an artist's later years. One such instance is the work of Henry Moore whose earliest life-drawings, done at the Royal College in the twenties, reveal from the outset a view of

the female figure which is consistently carried through into maturity. The sense of stillness, of impersonality, of monolithic forms in repose, which distinguish his later work clearly spring from the life-class and its influence. And where else could William Etty so safely have indulged his virgin passion for the female form save in the blessed sex-sanctuary of the Royal Academy Schools? But the majority of figure draughtsmen have done their best work far removed from the life-class. We must however qualify the use of the term "studio". During the past century this has come to mean something quite different from the popular idea of an artist's studio, so often imagined as a beautifully spacious room, lit with a north light and suitably appointed with a model's throne, screens, draperies, lay-figures and a discreet little model's dressing-room in a darkened corner. To-

day such places are usually the surgeries of the professional portrait-painter; the "specialist" of his trade, who needs to impress wealthy and stupid clients. Nowadays, in London, he will almost certainly live in Hampstead, the Harley Street of the portrait painter.

In modern times the best drawings of the nude have flowed from the bedroom; or even from the sofa. It is only necessary to find somewhere warm and private where you can pose your model. The kitchen would do. Many artists simply stand, or lay the girl on a rug in front of the fire. As an art student at the Royal College of Art in the thirties I particularly favoured the hearth-rug for my life drawing sessions at home; by which I mean my lodgings in Chelsea. The painter Ruskin Spear, a contemporary of mine at the College and a figure draughtsman of rare distinction, frequently drew

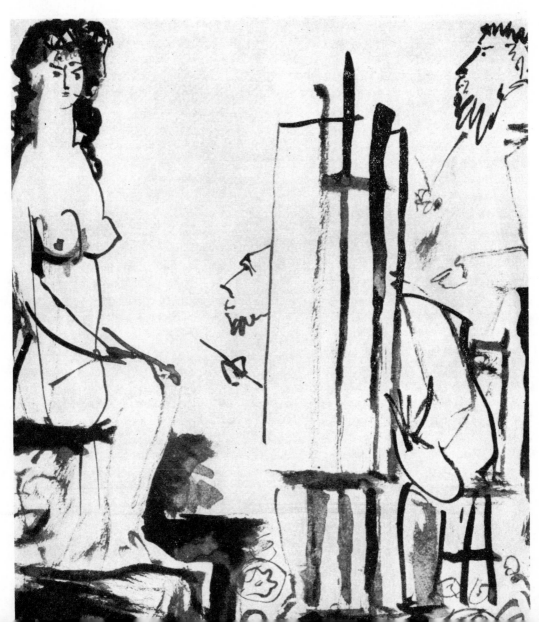

—and painted—his nudes on a bed in Hammersmith. The tender and sensitive drawing of his wife Mary (103) was drawn in such circumstances around 1937, shortly after he had left the Royal College. Sickert often worked in similar surroundings.

These are perhaps the most rewarding circumstances in which the artist can work from the nude, since they presuppose a fulfilment of relationship and consequently a relaxation of atmosphere. And this is most important. There should be the least possible tension between the artist and his subject. (For this reason it is easier to draw women after one has loved them. Most full-blooded painters would agree with this I think).

The informality, the relaxation, the tenderness of such drawings—Bonnard, Renoir, Vuillard, Marquet and many other French artists in particular approach the naked figure in this way—afford an exquisite, intimate view of the nude; a privileged glimpse of the artist's most treasured possession—his nude at home. In drawings such as these the prevailing mood is one of a tender and fulfilled rapport between the artist and his subject. But there are other circumstances in which the artist can draw from the nude, and in which a very different sort of atmosphere prevails. There is the bedroom in the brothel. Here such artists as Lautrec, Pascin and Degas found a less tender and more cynical source of inspiration. There is a cold, taut detachment about Pascin's drawing of a *Seated Girl* (59) which savours of an entirely different sort of relationship between the artist and model. There is no love lost here; the purveyor of lust is noted with a dispassionate and clinical eye. The artist reveals the incipient seeds of despair, decay, and futility; the stony path that Pascin himself was to tread and at the end of which, out of despair (of further pleasure) and decay (of his objectives as an artist) and futility (of his life), he committed suicide in 1930 while still only a relatively young man. For him the nude had been the pathway to self-destruction; the beauty of a woman's body a bitter and degraded emblem of lubricity. Yet he frequently draws with tenderness and compassion for the sad creatures (many of them little more than children) who are themselves in process of decay even as he notes their empty resignation. With less regard for the personality of their subjects both Lautrec (27) and Degas (31) have recorded intimate views of the brothel. Degas' *Conversation* provides one such key-hole glimpse of a prostitute and her client. That both Lautrec and Degas were men of remorseless detachment—Lautrec especially—seldom, if ever, emotionally involved with their nudes, is apparent from a study of their drawings. Degas was mostly, and coldly, concerned to show women as "animals in process of cleansing themselves".[1] They were analysts and commentators. They did not care about "personality" as did Pascin, out of compassion, or Rouault, who also drew prostitutes, out of a moral concern for their tragic (as he saw it) condition. Georges Rouault, a deeply religious man, wanted to show that evil—here (52) the evil of prostitution—was ugly; physically as well as morally ugly. He wanted to demonstrate that moral and physical ugliness are complementary. To this end he chose the symbol of the naked prostitute.

I ought to say a word here about the way in which an artist arrives at a pose. Earlier I described the cold, detached manner in which the drawing master sets a typical school pose. Artists of course "set" poses when working privately. Sometimes there is a good reason for this, especially if the drawing is to be a study for a figure composition. But from the point of view of drawing from the nude for its own sake, there is inevitably something artificial and unsatisfying about the set pose. One feels this in looking at contrived poses, such as the Derain (40) and the positioning of the model by William Frost (16) and William Mulready (44), both eminent Victorian draughtsmen. With all of these drawings one feels that the figure has been too carefully arranged; there is a stiffness about all three poses, as though the body itself were reluctant to accept the arrangement imposed upon it by the artist. They lack spontanaeity. In a manner of speaking the "set" pose is a betrayal of the body's naturalness; of its right to behave informally. The best poses are always those I would call "discovered poses". The artist suddenly *finds* the model in a position which instantly fires him to action. He is compelled to draw. Every model

[1] *The Hermitage*: Pierre Descargues (Thames & Hudson, 1961), p. 192.

will have heard at some time the urgent cry from the artist: "Stay like that!—don't move! I'll be as quick as I can—only for Christ's sake don't move! —that's a *wonderful* pose!" Maybe the pose will be a difficult one to keep, or it may be easy and relaxed, but the artist's only concern is to get the model to hold it long enough for him to make a lively and spontaneous notation. Into this category fall such obviously informal and "discovered" positions as Segonzac's *Nu Allongé* (77), Suzanne Valadon's *Nu a l'eponge* (53), the exquisite Vuillard studies of a dancer undressing (42) and many other drawings in this book.

So far I have been talking about direct working

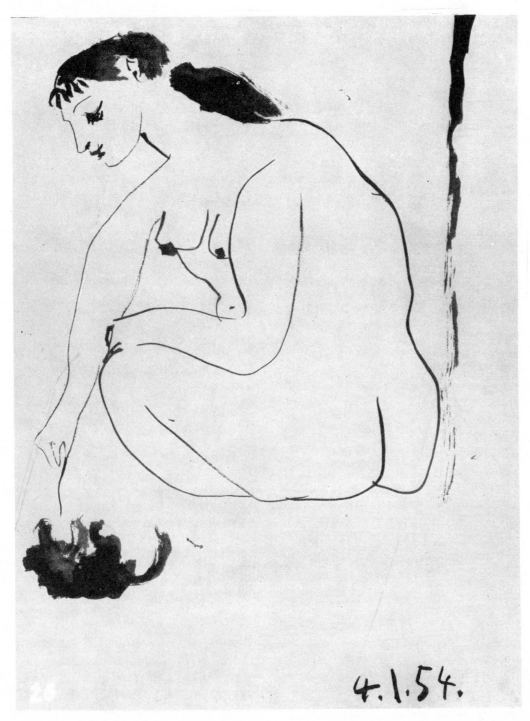

4.1.54.

from the nude, from the living nude on the spot. But many artists have drawn the nude straight from the imagination. Let me consider Goya and Fuseli in this connection. Both were artists of passionate, even terrible imagination. Both were haunted men. Goya, in his later years morose, lonely, a victim of syphilitic ill-health, of which deafness as total as Beethoven's was only one manifestation, made the two drawings here reproduced (9) in his late sixties. They are part of a series in sepia which he produced between the years 1800 and 1823, and reveal his continual obsession with nightmare subjects in which the violation and destruction of the human body symbolises all the deepest and most profound of human fears and terrors. Flesh torn and ripped, entrails gutted and devoured, bodies falling helplessly and horribly through unfamiliar and sinister spaces, twisted and tormented in agony, often for no apparent reason. Almost a foreshadowing of Kafka. André Malraux has written of this particular vein in Goya's art:[1] "A psychoanalyst would consider Goya devoured by symbols; and it is true that he was almost brutally sensitive to these demons of terror which are immediately recognisable as common to us all; not only physical torture, but humiliation, nightmare, rape, gaol. . . ." In this sense Goya expressed in drawings such as these something of the perennial pattern of fear and terror which has haunted the collective unconscious since man first began to materialise the shape of his demons in his imagination and his dreams. It is natural that these should come to roost in the form of the naked body since the whole concept of human suffering and pain is most conveniently expressed in images of physical agony, in visions of naked flesh, defenceless and unprotected. To deprive man of his clothes is in itself an act of degradation. Goya makes good use of this fact. And anyway, is not nakedness an essential condition of man's ultimate damnation? Consider the hells of Hieronymus Bosch. Goya lived through an era of considerable violence, and many of the drawings in the series from which these two are taken were prompted no doubt by the horrors of revolution and civil war. Goya's titles are almost always cryptic. Sometimes they

afford a clear and definite clue to the understanding of a drawing ("They say nothing" suggests the impotence of the suffering and the tortured); others ("These witches will tell") are apparently meaningless. Malraux suggests that Goya must frequently have added his titles after a drawing was made, thus using the involuntary techniques of the modern surrealist painter. "He drew as if in his sleep," wrote Malraux, "and even stated that in the *Visions of a Night* he had drawn what he dreamt." Yet whatever the psycho-analytical explanation of these titles, there is no denying the immense force and impact of these portrayals of the nude, nor their relevance as a symbolic expression of the face of terror when it assumes the guise of an irrational agency.

Fuseli's view of the nude is equally haunted, though in a far more restricted and specific sense. Where Goya applied his imagination to the expression of suffering, fear and terror, Fuseli was absorbed and haunted by sexual fantasies of demonic intensity. Yet he too is expressing a common theme: the overwhelming potency of sexual passion, and of desire, however devious and bizarre. Fuseli, a contemporary of William Etty and a fellow member of the Royal Academy (he eventually became Keeper of the Royal Academy Schools) was born in Zurich in 1761. In 1778, after a long round of wanderings in Europe he settled in London and began that strange series of erotic drawings (some of them still listed, ludicrously, as too obscene for publication) which deal with the more *outré* aspects of sexual deviation. Hair fetishism plays an important part in these drawings, and his women are often depicted as threatening and sadistic figures attired, to use Ruthven Todd's description "in parodies of the long, clinging dresses of the period". These curious and dreadful figures affect monumental hair stylings, exposed breasts, and sometimes long gloves and switches. As symbols of authority and dominance they clearly reveal the masochistic corner of the artist's personality, and his desire to be threatened, dominated, and even physically ill-treated by women of overbearing personality. But occasionally, as in the drawing of a *Young Man Kissing a Woman at a Spinet* (74) the tables are turned and the lamb is suddenly and startlingly transformed into a tiger. The voluptuousness of

[1] *Goya: Drawings from the Prado*, p. xx, Horizon, 1947.

the drawing is magnified by the thrust of the breasts and nipples under the close clinging draperies. It is a study of breathtaking eroticism with the ecstasy already mounting to a crescendo of bliss as the man swings back the woman's head for the stab of his kiss. More tender is the drawing *The Kiss* (74) one of the few studies in which Fuseli seems to have reconciled all the warring elements in his extraordinary sexual make-up. By all accounts he was a small, physically unattractive fellow; "a little white-headed lion-faced man in an old flannel dressing-gown" to quote a contemporary, the painter Benjamin Haydon. Fuseli, the insignificant man of fierce imagination, whose childless marriage, and pathetic, bloodless intrigue with Mary Wollstonecraft Shelley suggest a life of marked sexual inferiority, here uses the image of the female nude as the basis of a robust, dream-like fulfilment of his sexual inadequacies. Doubtless the artist found a deep, vicarious satisfaction in the making of such studies. The secret sex-life of an eighteenth-century Walter Mitty is fascinatingly disclosed in his drawings. So intriguing is the art of this astonishing master of the erotic imagination that I would refer my reader to Paul Ganz's study, *The Drawings of Henry Fuseli*, published by Max Parrish in 1949.

More often than not the artist draws the nude for his own pleasure. But he can, as we have seen, use it deliberately as a means of social comment. This is quite apart from the making of drawings which indirectly provide us with keys to the nature of a social order, or a particular way of life: such as the art of the French Court; or the drawings of Alphonse Mucha (101) which epitomise the spirit of *art nouveau* and illuminate the character of an aesthetic style vested in the sweeping curve, a passion for nature, and echoing the erotic decadence which marked the art forms of the *fin de siécle*. The difference between the two approaches is in the act of deliberation. For example, the German master Georg Grosz makes frequent use of the nude as an element of satire. The greatest political and social satirist since Goya and Daumier, Grosz bitterly depicted the moral decay of Germany in the early twenties. His drawings of war profiteers indulging in their lusts and perversions are withering comments on the nature of a deeply corrupt and sick society (18). In a

different vein Picasso has used the nude as part of a satirical plan, in the series of drawings which illustrate this introduction. Between November 1953 and February 1954, working in a frenzy of inspiration, Picasso produced some hundreds of drawings on the theme of the relationship between the artist and his model. Some "authorities" say this series numbered a total of 180 drawings, but Louis Aragon is quoted as saying:[1] "If, as has been suggested, Picasso followed a single line of thought for more than two months the result would not have been 180 drawings but, as we know, between a thousand and two thousand." The point is perhaps immaterial, except that it illustrates the probable extent of the artist's incredible energy, and the legend of that energy. For at the time this series was created Picasso was seventy-two. In the main, the drawings depict an elderly, decrepit painter working from the figure of a beautiful and voluptuous girl. The series is a robust, often extremely comic satire on the impotence of the intellectual approach to the problem of portraying an essentially sensuous, non-intellectual subject. The absurdity of this approach is splendidly ridiculed by the icy indifference of the model herself, and by the ludicrous figure of the artist peering short-sightedly at a beauty he can never hope to capture, let alone understand and enjoy. Sometimes the painter is transformed into an ape, or seen as a clown chattering with the model during a rest period. At other times the studio is suddenly possessed by troupes of frenzied bacchantes who dance wildly to the pipes of a fat, bearded faun. This manifestation also is a protest against the sterility of the academic-intellectual approach to the sensuous clamourings of the flesh. In her introduction to the Catalogue of the 1955 Exhibition of a selection of these drawings,[2] Miss Rebecca West says: "The drawings become a howl of protest against artists who are not sensuous and who become intellectuals but not intelligent. . . . Why is Picasso so hard on the stupid? Because he is so acutely conscious the body is clever." By cleverness of the body Miss West means, of course, the body's essential and inviolable naturalness; its

[1] *Picasso:* Antonina Vallentin, p. 248 (Cassell, 1963).

[2] *Picasso:* 63' Drawings, 1953–54. Marlborough Fine Art: May-June 1955.

right to live a life of its own, and to impose that life, and its own sensuous identity, upon the forms of art. Because academic and intellectual art seeks to direct that life into mean, narrow and bigoted ends, it must inevitably fail. Very largely this is the message of these drawings. But the series is also an attack upon the substitution of the cerebral for the erotic. The artist uses his painters, clowns and buffoons to expose the absurd nature of sexual impotence in the face of pure, sensual beauty. The clown chatters emptily and the buffoon clowns, as a cover, a mask, for their degrading ineptitude, just as people grin and laugh ostentatiously to hide their fear, or inadequacy. This remarkable series is therefore a satirical double allegory on the nature of intellectual and sexual impotence.

<div align="center">★</div>

It has not been my intention to comment here on more of the drawings reproduced in this book than was necessary to illustrate my arguments. To comment on all would be presumptuous, for the drawings can well speak for themselves. The critic is at worst a pretentious meddler, at best a humble pointer of directions. The sooner he shuts up and

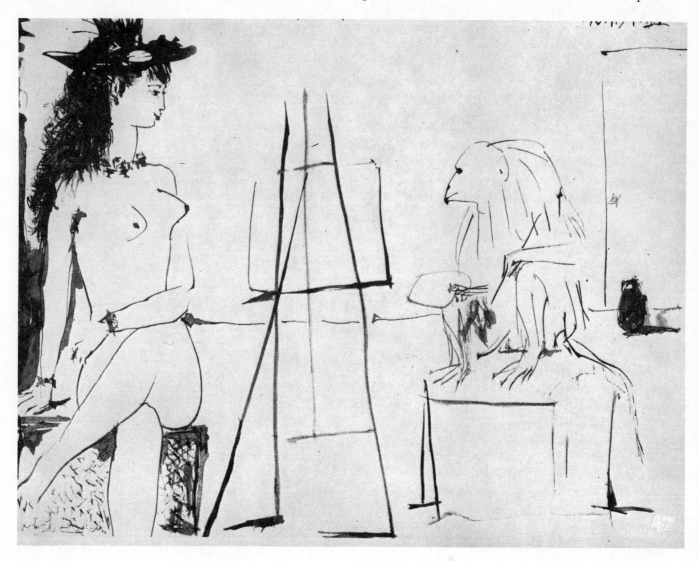

lets the work of art get on with it, the better. (No artist of spunk gives a damn about critics).

I will finish, however, with a word about my own preferences. I get the keenest pleasure from drawings which are essentially spontaneous, in which there is the smallest time lag between the feeling—the desire—the ache to draw, and its expression. Drawings in which there has been no time for emotion to evaporate or run to seed in the sludge of some labourious technical style. Even in the brash bravura of Epstein or John there is much pleasure to be derived from the sheer immediacy and impact of spontaneity. But there are drawings in which only the merest tremble of line·

separates the emotion from its expression, and this is the drawing of the great masters. Into this category come the line drawings of Rodin, and those inexpressibly delicate and beautiful early studies of Picasso, such as the *Deux Nus* (41). There is here a distillation of emotion, so rare, so refined, a communication of spirit so bathed in poetry and compassion, so tender and moving, that the heart melts. There is no problem of communication here, nor the need of any further words from me.

MERVYN LEVY

London 1965

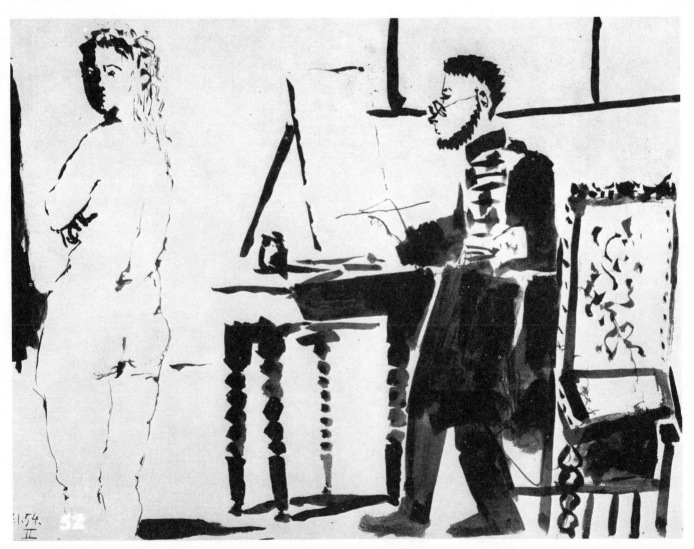

The Drawings

1. Pierre-Auguste Renoir (1841–1919)
 Study for "The Bathers". 1885.
 Sanguine and black crayon. $34\frac{1}{2} \times 21\frac{1}{4}$ in. (86 × 54 cm.)
 Collection M. Hugo Perls.

2. John Constable (1776–1837)
 Male nude.
 Pencil. $21 \times 12\frac{1}{2}$ in. (8·25 × 5 cm.)
 Collection Lt-Col. J. H. Constable.

3. André Derain (1880–1954)
 Standing nude.
 Red chalk. 25 × 19 in. (63·5 × 48 cm.)
 Collection Mrs. Dominique Mann.

4. Egon Schiele (1890–1918)
 Nude woman sitting with drawn-up knees.
 Charcoal. $18\frac{3}{4} \times 11\frac{3}{4}$ in. (47·5 × 30 cm.)
 Albertina, Vienna.

5. Pierre-Paul Prud'hon (1758–1823)
 Study for the figure of Innocence for the painting "L'Amour séduit l'Innocence".
 Black and white chalk. $21\frac{1}{2} \times 11\frac{1}{2}$ in. (8·5 × 4·5 cm.)
 Collection George Farrow Esq.

6. Allen Jones (b. 1937)

 Top. Variations on Today. 1963.
 Chalk. $17 \times 11\frac{3}{4}$ in. (43 × 30 cm.)
 Collection Mrs. Allen Jones.

 Bottom. Figure Study. 1963.
 Pencil. 20 × 9 in. (51 × 23 cm.)
 Collection Barry Miller Esq.

7. Augustus John (1878–1961)
 Pencil. $11 \times 9\frac{1}{2}$ in. (28 × 24 cm.)
 Collection Joseph Fitton Esq.
 By courtesy of Mrs. Augustus John.

8. Edgar Degas (1834–1917)
 After the Bath: woman drying her feet.
 Charcoal and pastel. $22\frac{1}{2} \times 16$ in. (57 × 41 cm.)
 The Art Institute of Chicago.

9. Francisco de Goya (1746–1828)

 Top. "These witches will tell."

 Bottom. "They say nothing."

 Both. Sepia. $4 \times 2\frac{1}{2}$ in. (10 × 6·5 cm.)
 Prado, Madrid.

10. Alfred Stevens (1818–75)
 Red chalk. $11\frac{3}{4} \times 8\frac{3}{4}$ in. (29·5 × 22 cm.)
 Victoria and Albert Museum, London.

11. Henri Gaudier-Brzeska (1891–1915)

 Top. Pen and ink. 15 × 8 in. (38 × 20 cm.)

 Bottom. Charcoal. 20 × 15 in. (51 × 38 cm.) 1919.

 Both. Victoria and Albert Museum, London.

12. *Top*. Peter Blake (b. 1932)
 Pin-up girl. 1962.
 Pen, pencil and wash. $11 \times 8\frac{1}{2}$ in. (28 × 21·5 cm.)
 From "Motif" no. 10.
 By courtesy of the Shenval Press Ltd.

 Bottom. Yasuo Kuniyoshi (1893–1953)
 Two figures. 1925.
 Pen, dry brush and ink. 22 × 15 in. (56 × 39·5 cm.)
 The Museum of Modern Art, New York.

13. Jules Pascin (1885–1930)
Pencil and charcoal. 16 × 12 in. (40 × 40·5 × 30·5 cm.) c. 1910.
Private collection, London.

14. Paul Delvaux (b. 1898)
Reclining nude. c. 1935.
Pen and indian ink. 15 × 21 in. (38 × 53 cm.)

15. Jules Pascin (1885–1930)
Reclining nude. 1928.
Charcoal. 20 × 25½ in. (51 × 65 cm.)
The Museum of Modern Art, New York.

16. William Frost (1810–77)
Black and white chalk. 18 × 13½ in. (46 × 34 cm.)
Victoria and Albert Museum, London.

17. Georges Seurat (1859–91)
Black conté. 13 × 19 in. (33 × 48 cm.) c. 1882.
The Courtauld Institute of Art, London.

18. Georg Grosz (1893–1959)
Top. Pen and ink. 12½ × 7¾ in. (31 × 19·5 cm.)
Bottom. Courtship. 1921.
Pen and indian ink. 15½ × 11½ in. (39·5 × 29 cm.)
Both. By courtesy of the Georg Grosz Estate.

19. Renato Guttuso (b. 1912)
Algerian woman naked. 1960.
Oil sketch.

20. Jean-Louis Forain (1852–1931)
Black chalk and wash. 12½ × 16½ in. (32 × 42 cm.)
The Courtauld Institute of Art, London.

21. Auguste Rodin (1840–1917)
Aphrodite and Adonis.
Pen and water colour. 8¼ × 11½ in. (21 × 29 cm.)
Private collection, England.

22. Aristide Maillol (1861–1944)
Nu accroupi. 1939.
Sanguine. 13½ × 10½ in. (34 × 26·5 cm.)
Collection J. P. Durand-Matthiesen, Geneva.

23. Jackson Pollock (1912–56)
Two drawings.
Pencil and crayon. 14 × 17 in. (35·5 × 43 cm.) c. 1931.
By courtesy of Mrs. Lee Krasner Pollock and the Thames and Hudson archives, London.

24. Theodore Géricault (1791–1824)
Le Baiser. 1882.
Sepia and black chalk, heightened with white.
8 × 10½ in. (20·5 × 26·5 cm.)
Private collection, America.

25. Egon Schiele (1890–1918)
Lovers. 1918.
Charcoal. 19¼ × 13 in. (49 × 33 cm.)
Collection Mervyn Levy Esq.

26. Walter Sickert (1860–1942)
Charcoal and white chalk. 14½ × 9½ in. (37 × 24 cm.). 1915.
The Royal College of Art, London.

27. Henri de Toulouse-Lautrec (1864–1901)
Fillette nue. 1893.
Painting on cardboard. 23¼ × 15½ in. (59 × 39 cm.)
Musée Toulouse-Lautrec, Albi, France.

28. Dominique Ingres (1780–1867)
Study for "L'Age d'Or".
Pen and pencil. 8½ × 12¼ in. (21·5 × 31 cm.)

29. Adolf Menzel (1815–1905)
Weibliche Akte.
Pencil. 9 × 11½ in. (23 × 29 cm.)
Nationgalerie, Berlin.

30. Pablo Picasso (b. 1881)
Rape. 1940.
Brush and ink.

31. Edgar Degas (1834–1917)
Conversation. c. 1879.
Monotype. 6¼ × 4½ in. (16 × 11·5 cm.)
Collection G. Corcoran Esq.

32. Théodore Fantin-Latour (1836–1904)
Chalk.

33. Charles Cajori (b. 1921)
Pencil. 14 × 10½ in. (35·5 × 26·5 cm.) 1963.
The Howard Wise Gallery, New York.

34. Henry Moore (b. 1898)
Seated female nude. c. 1928.
Ink and wash. 14½ × 18 in. (37 × 45·5 cm.)
Private collection, Canada.

35. Jacob Epstein (1880–1959)
Sumita. 1938.
Pencil.
By the courtesy of Lady Epstein.

36. Reg Butler (b. 1913)

Top. Crazy Horse. 1960.
Pencil. 24 × 20 in. (61 × 51 cm.)
Collection Sir Duncan and Lady Oppenheim.

Bottom. Ophelia. 1960.
Pencil. 35½ × 23½ in. (90 × 59·5 cm.)
Collection E. P. Eckhoff Esq.

37. William Etty (1787–1849)
Pencil heightened with white. 21 × 13 in. (53 ×
 33 cm.)

38. Amedeo Modigliani (1884–1920)
Oil, water colour and pencil. 25½ × 19½ in. (65 ×
 49·5 cm.)

39. Charles Despiau (1874–1946)
Nue couchée.
Sepia. 11½ × 10 in. (29 × 25·5 cm.)
Collection G. Corcoran Esq.

40. André Derain (1880–1954)
Nu assis.
Pencil. 24¾ × 13¾ in. (63 × 35 cm.)
Private collection, Switzerland.

41. *Top*. Pablo Picasso (b. 1881)
Deux Nus. 1905.
Ink. 4½ × 3 in. (11·5 × 7·5 cm.)

Bottom. William Etty (1787–1849)
Pencil. 6 × 4½ in. (15 × 11·5 cm.)
Collection Anthony Adams Esq.

42. Edouard Vuillard (1868–1940)
Nue et danseuse.
Charcoal. 20½ × 15¼ in. (52 × 35·5 cm.)
Collection G. Corcoran Esq.

43. *Top*. Henri Gaudier-Brzeska (1891–1915)
Cubist figure study.
Pencil. 13 × 8 in. (33 × 20·5 cm.)

Bottom. Hans Bellmer (b. 1902)
Woman on a sofa. 1956.
Pencil. 12½ × 15½ in. (32 × 39·5 cm.)
Collection Barry Miller Esq.

44. William Mulready (1786–1883)
Chalk. 20 × 11 in. (51 × 28 cm.)
Victoria and Albert Museum, London.

45. Paul Cézanne (1839–1906)
Nu assis, vu de dos. c. 1862.
Charcoal. 24¾ × 18 in. (63 × 46 cm.)

46. Avinash Chandra (b. 1931)

Top. Black ink. 16 ft. long. (490 cm.) 1963.

Bottom. Black ink. 6 ft. long. (183 cm.) 1963.

47. Paul Cézanne (1839–1906)
Bacchanale. 1885.
Chalk and water colour.

48. Paul Klee (1879–1940)
Angeleliut (Leaning). 1938.
Pencil. 30 × 21 in. (76 × 53·5 cm.)
Bildarchiv Felix Klee, Bern.

49. Raoul Dufy (1877–1953)
Standing nude.
Pencil. 11 × 8½ in. (28 × 21·5 cm.)
Collection Mrs. Angela Einstein.

50. William Hogarth (1697–1764)
Seated nude male Academy figure as a Barbary
 captive.
Black and white chalk. 12 × 8¾ in. (30·5 × 22 cm.)
Collection W. A. Brandt Esq.

51. William Hogarth (1697–1764)
Seated nude female Academy figure.
Black and white chalk. 13 × 8½ in. (33 × 21·5 cm.)
Collection The Hon. Christopher Lennox-Boyd.

52. Georges Rouault (b. 1871)
Water colour.

53. Suzanne Valadon (1865–1938)
Nu à l'eponge. 1892.
Charcoal. 5½ × 5¼ in. (14 × 13·5 cm.)
Collection G. Corcoran Esq.

54. Pierre-Auguste Renoir (1841–1919)
Buste de femme. c. 1890.
Charcoal. 24 × 18 in. (61 × 46 cm.)
Collection G. Corcoran Esq.

55. Pierre Bonnard (1867–1947)
Chalk.

56. Auguste Rodin (1840–1917)

Top. Pencil and water colour. 10 × 9¼ in. (25·5 × 23·5 cm.)

Bottom. Pencil and water colour. 9 × 12½ in. (23 × 32 cm.)
Both. Victoria and Albert Museum, London.

57. Aristide Maillol (1861–1944)
Nu de dos.
Pencil. 10½ × 6¼ in. (26·5 × 16 cm.)

58. Edouard Manet (1832–83)
Study for "Olympia".
Sanguine. 9¾ × 18 in. (25 × 45·5 cm.)
Musée du Louvre, Paris.

59. Jules Pascin (1885–1930)
Seated girl.
Water colour and pencil. 12¼ × 8½ in. (31 × 21·5 cm.)
The Museum of Modern Art, New York.

60. François Boucher (1703–70)
Le Bain de Vénus.
Pencil heightened with white. 11½ × 9¼ in. (29 × 23·5 cm.)
University of Charkow, Museum of History of Art.

61. Ernst Ludwig Kirchner (1880–1938)
Pastel. 17½ × 13½ in. (44·5 × 34 cm.) c. 1907.
The Courtauld Institute of Art, London.

62. Pablo Picasso (b. 1881)
Nu couché. 1919.
Pencil. 8 × 10½ in. (20·5 × 26·5 cm.)
Private collection, Canada.

63. Edgar Degas (1834–1917)
Repos sur le lit.
Monotype. 4¾ × 6½ in. (12 × 16·5 cm.)
Collection G. Corcoran Esq.

64. Théophile-Alexandre Steinlen (1859–1923)
Charcoal. 17 × 19 in. (43 × 48 cm.)

65. Gustave Klimt (1862–1918)
Pregnant nude.
Pencil. 17½ × 12 in. (44·5 × 30·5 cm.)

66. Henri Gaudier-Brzeska (1891–1915)
Charcoal. 20 × 15 in. (51 × 38 cm.) 1919.
Victoria and Albert Museum, London.

67. Albert Marquet (1875–1947)
5 × 6¼ in. (12.5 × 16 cm.) c. 1900.
Private collection, Germany.

68. Egon Schiele (1890–1918)

Top. Reclining nude. 1917.
Pencil. 18 × 11½ in. (46 × 29 cm.)

Bottom. Self portrait for the painting "The Family". 1918.
Black charcoal. 12 × 18½ in. (30 × 47 cm.)
Albertina, Vienna.

69. Henri Matisse (1869–1954)
Charcoal. 24 × 16 in. (61 × 40·5 cm.) 1938.

70. Alexander Archipenko (b. 1887)
Femme nue assise.
Pencil. 19 × 12¾ in. (48 × 32·5 cm.)
Collection A. Haskell Esq., C.B.E.

71. Jean-Louis Forain (1852–1931)
Nu de dos.
Red chalk. 10 × 7¾ in. (25·5 × 20 cm.)
Collection Mrs. Dominique Mann.

72. Henry Moore (b. 1898)
Seated figure. 1932.
Pen and wash. 17 × 13½ in. (43 × 34·5 cm.)
Cherll Collection.

73. Amedeo Modigliani (1884–1920)
Caryatid. c. 1913.
Pencil. 21½ × 17½ in. (55 × 45 cm.)
The Tate Gallery, London.

74. Henry Fuseli (1741–1825)

Top. The Embrace. c. 1815.
Chalk. 8½ × 6 in. (21·5 × 15·5 cm.)
Offentliche Kunstsammlung, Basle.

Bottom. The Kiss. 1819.
Pencil and black chalk. 9 × 8 in. (24·5 × 20 cm.)
Kunsthaus, Zurich.

75. Salvador Dali (b. 1904)
Etude de nu. 1950.
Red crayon and ink. 13¾ × 10¾ in. (35 × 27 cm.)

76. Henri Matisse (1869–1954)
Reclining nude.
Pen. 13 × 19 in. (33 × 48 cm.)

77. André Dunoyen de Segonzac (b. 1884)
Nu allongé.
Pen and ink. $6\frac{3}{4}$ × 10 in. (17 × 25·5 cm.)

78. Albert Marquet (1875–1947)

Top. Drawing.

Bottom. Seated nude.
Brush and chinese ink. 11 × $6\frac{3}{4}$ in. (28 × 17 cm.)

79. Oskar Kokoschka (b. 1886)
Drawing for Albert Ehrenstein's "Tubutsch".
1911.
Pen and ink.

80. Augustus John (1878–1961)
Pen. $12\frac{1}{4}$ × 14 in. (31 × 35·5 cm.)
By the courtesy of Mrs. Augustus John.

81. Henry Moore (b. 1898)
Standing figure. 1928.
Chalk and brush. 21 × 13 in. (53 × 33 cm.)

82. Constant Permeke (1886–1954)
L'Adolescente. 1937.
Painting on paper. $45\frac{1}{4}$ × $23\frac{1}{2}$ in. (60 × 150 cm.)
Collection Paul Haesaerts.

83. Stanley Spencer (1891–1959)
Study of the nude male.
Pencil. $21\frac{3}{4}$ × $14\frac{1}{4}$ in. (55 × 36 cm.)

84. *Top*. Emilio Greco (b. 1913)
Pen, dry brush and ink. 12 × $14\frac{3}{4}$ in. (30 × 37·5 cm.)

Bottom. William Scott (b. 1913)
Reclining nude. 1956.
Charcoal. $29\frac{1}{2}$ × 82 in. (75 × 108 cm.)

85. Auguste Rodin (1840–1917)
Nue assise. c. 1900.
Pencil. $13\frac{1}{2}$ × 11 in. (34 × 28 cm.)
The Courtauld Institute of Art, London.

86. Henr Matisse (1869–1954)
Nu assis. c. 1953.
Pen and indian ink. $10\frac{1}{2}$ × $8\frac{1}{4}$ in. (27 × 21 cm.)
Private collection.

87. Henri Matisse (1869–1954)
Chalk.

88. Antoine Watteau (1684–1721)
Etude de femme.
Musée du Louvre, Paris.

89. Jacob Epstein (1880–1959)
Nan seated. 1911. Study for a bronze figure
which is now in the Fitzwilliam Museum,
Cambridge.
Pencil.
By courtesy of Lady Epstein.

90. Fausto Pirondello (b. 1889)

Top. Seated woman.
Indian ink. $11\frac{1}{2}$ × $8\frac{3}{4}$ in. (29 × 22 cm.)

Bottom. Mother and child on beach.
Indian ink. 11 × $8\frac{1}{2}$ in. (28 × 22 cm.)

91. Charles Despiau (1874–1946)
Figure drawing.
Brown chalk. 15 × 11 in. (35 × 28 cm.)
Victoria and Albert Museum, London.

92. Georg Kolbe (1877–1947)
Seated nude. c. 1924.
Dry-point. $10\frac{1}{2}$ × $8\frac{1}{4}$ in. (27 × 21 cm.)
Courtauld Institute of Art, London.

93. Alexander Archipenko (b. 1887)
Standing nude.
Pencil. $13\frac{1}{2}$ × $10\frac{1}{2}$ in. (34·5 × 26·5 cm.)
Collection Mrs. Harry Remis.

94. *Left*. Otto Dix (b. 1891)
Girl in a petticoat.
Pencil. $16\frac{1}{2}$ × $11\frac{1}{2}$ in. (42 × 29 cm.)
Galleria Gallatea, Turin.

Right. Aristide Maillol (1861–1944)
Black pencil. $11\frac{1}{4}$ × $7\frac{1}{2}$ in. (28·5 × 19 cm.)

95. Alphonse Mucha (1860–1939)
Nude sitting on tree with sketch of snakes, exe-
cuted in 1904 for "Figure dans la Décoration".
Charcoal $17\frac{1}{4}$ × $22\frac{3}{4}$ in. (44 × 57·5 cm.)
By courtesy of M. Jiri Mucha.

96. Paul Gaugin (1848–1903)
Standing female nude. 1892.
Pen, brush and ink. 6 × $3\frac{1}{2}$ in. (15 × 9 cm.)
Helen Serger Fine Arts, New York.

97. Eugène Delacroix (1798-1863)
Girls wrestling.
Pencil. $8\frac{3}{4} \times 10\frac{1}{2}$ in. (22×27 cm.)
Musée del Louvre, Paris.

98. Elie Nadelman (1885-1946)
Two figures. c. 1914.
Pen and ink. $14\frac{1}{2} \times 12$ in. (37×30.5 cm.)
The Museum of Modern Art, New York.

99. Suzanne Valadon (1865-1938)
Nu debout. 1908.
Crayon. $22\frac{3}{4} \times 15\frac{1}{4}$ in. (56×38.5 cm.)
Collection G. Corcoran Esq.

100. F. .N. Souza (b. 1924)
Two drawings.
Pen and ink. 11×8 in. (28×20.5 cm.) 1962.
Collection Mervyn Levy Esq.

101. Alphonse Mucha (1860-1939)
Drawing for "Lis" in "Les Fleurs". 1897.
Black chalk.
By courtesy of M. Jiri Mucha.

102. *Top.* Thomas Rowlandson (1756-1827)
Man and woman dancing—after the antique.
Pen and brown ink. $5 \times 3\frac{1}{4}$ in. (12.5×8.5 cm.)
The Cherll Collection.

Bottom. André Derain (1880-1954)
Chalk.

103. Ruskin Spear (b. 1911)
Pen and ink and red chalk. $21\frac{1}{4} \times 12\frac{1}{4}$ in. (54×31 cm.) c. 1938.
Collection The Artist.

104. Jean Fautrier (b. 1897)
Drawing for "Bataille".
Indian ink and crayon. $10 \times 7\frac{1}{2}$ in. (25.5×19 cm.)
Hanover Gallery, London.

105. Horace Brodzky (b. 1885)
Pen. $16 \times 9\frac{3}{4}$ in. (40.5×25 cm.) 1936.
Collection. Mervyn Levy Esq.

106. *Top.* Oskar Kokoschka (b. 1886)
Standing nude. c. 1919.
Brush and indian ink. $25\frac{1}{2} \times 17$ in. (65×43 cm.)
Collection Richard Feigen Gallery, New York.

Bottom. Carel Weight (b. 1908)
Eve. c. 1952.
Pencil. 13×5 in. (34×14.5 cm.)
The Royal College of Art, London.

107. Edgar Degas (1834-1917)
Etude de nus, quatre figures. 1900.
Charcoal. $20 \times 17\frac{1}{2}$ in. (51×44.5 cm.)
Collection M. G. Hervé, Paris.

108. Pierre-Auguste Renoir (1841-1919)
Femme nue s'essuyant le pied.
Charcoal and sanguine. $17 \times 11\frac{1}{4}$ in. (43×28.5 cm.)
Collection W. Spears Esq., Birmingham.

109. Augustus John (1878-1961)
Kneeling nude. 1899.
Charcoal. $9\frac{1}{2} \times 7\frac{1}{4}$ in. (24×18.5 cm.)
Collection J. A. F. Binny Esq., London.
By courtesy of Mrs. Augustus John.

110. Gaston Lachaise (1882-1935)

Top. Walking woman, profile. c. 1933.
Pencil. $24\frac{1}{4} \times 19$ in. (61.5×48 cm.)

Bottom. Seated woman. c. 1930.
Pencil. 24×19 in. (61×48 cm.)

Both. The Museum of Modern Art, New York.

111. Joshua Reynolds (1723-92)
Pencil. $16 \times 11\frac{1}{4}$ in. (40.5×28.5 cm.)
Collection Spink & Son Ltd.

112. Roger de la Fresnaye (1885-1925)
Torse de femme nue.
Pencil. $12\frac{1}{2} \times 8\frac{1}{4}$ in. (32×21 cm.)
Collection G. Corcoran Esq.

The Picasso drawings which decorate the introduction were first published in *Verve* vol. VIII no. 29-30 *(S.P.A.D.E.M., Paris, 1965).*

We are indebted to the following galleries and firms for their assistance, and for supplying photographs, as well as to those who are credited elsewhere with ownership.

Durand-Ruel et Cie, Paris: Renoir (1).

Alex Reid & Lefevre, London: Derain (3 & 40); Delraux (14); Dufy (49); Picasso (62); Archipenko (70); Forain (71); Dali (75); Segonzac (77); Marquet (78 bottom); Permeke (82).

Arthur Tooth & Sons Ltd., London: Allen Jones (6); Stanley Spencer (83); Augustus John (109).

Roland Browse & Delbanco, London: Pascin (13); Maillol (57); Cézanne (47); Maillol (94 bottom).

The Piccadilly Gallery, London: Grosz (18); Gaudier-Brzeska (43 bottom); Klimt (65); Dix (94 top).

Wildenstein & Co. Ltd., London: Rodin (21); Boucher (60).

The Sabin Galleries, London: Rowlandson (102 top).

Mr and Mrs Ruskin Spear (103).

The Marlborough Gallery, London: Henry Moore (34, 72 & 81); Kirchner (61); Schiele (68); Matisse (69); Kokoschka (106).

The Hanover Gallery, London: Reg Butler (36); Matisse (86); Fautrier (104).

The Grosvenor Gallery, London: Modigliani (38); Picasso (41); Matisse (76); Greco (84); Pirondello (90); Matisse (87); Mucha (95).

The Hamilton Galleries, London: Chandra (46).

P. & D. Colnaghi & Co. Ltd., London: Hogarth (50 & 51).

The Crane Kalman Gallery, London: Steinlen (64).

Sotheby & Co., London: Gaugin (96); Degas (107); Renoir (108); Augustus John (109); Reynolds (111); La Fresnaye (112).

As much information as possible has been included in this list, but many dates are missing since, in the nature of these drawings, they were not recorded. In a few cases it has proved impossible to trace the original sizes, or the present whereabouts, of drawings.

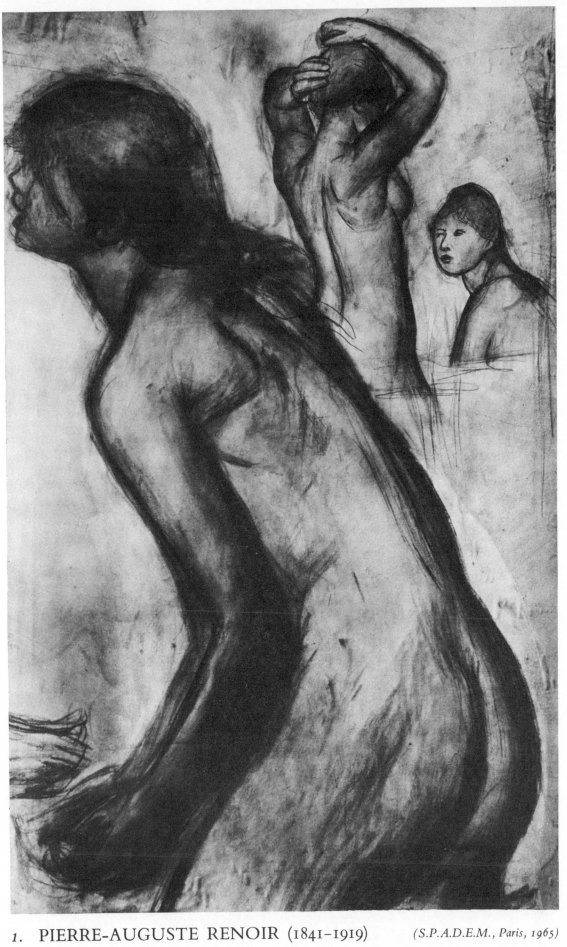

1. PIERRE-AUGUSTE RENOIR (1841–1919) *(S.P.A.D.E.M., Paris, 1965)*

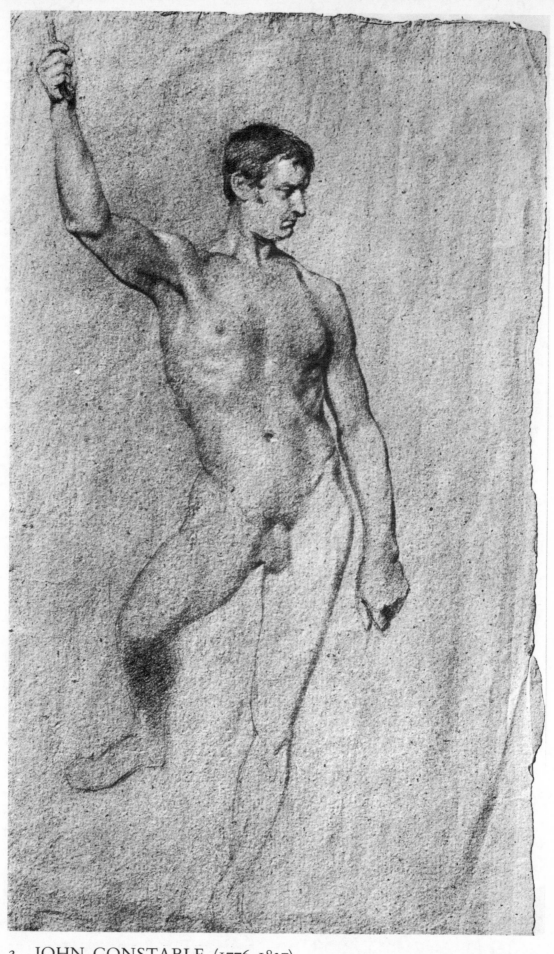

2. JOHN CONSTABLE (1776–1837)

ANDRE DERAIN (1880-1954)

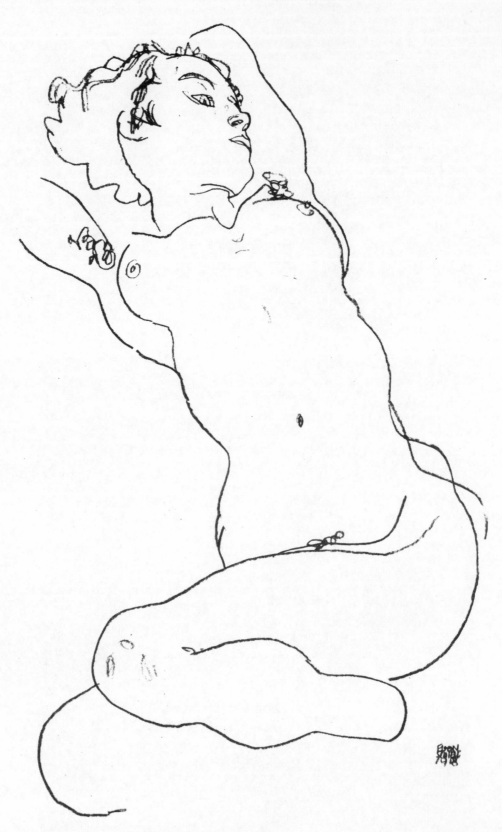

4. EGON SCHIELE (1890–1918)

5. PIERRE-PAUL PRUD'HON (1758–1823)

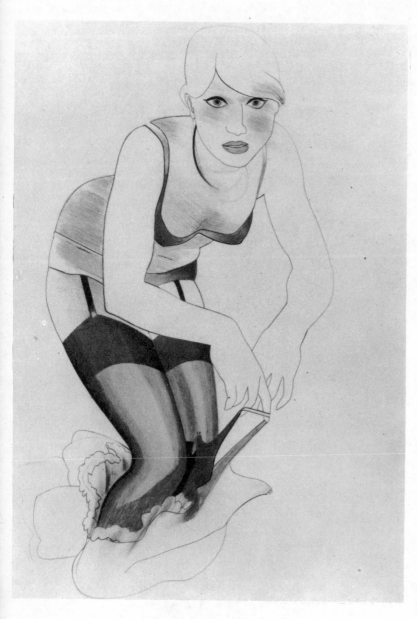

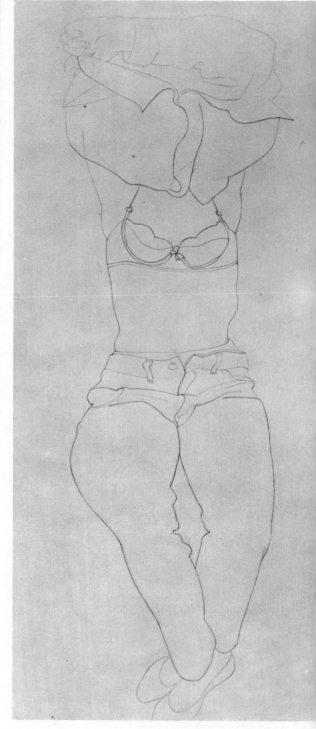

6. ALLEN JONES (1937–)

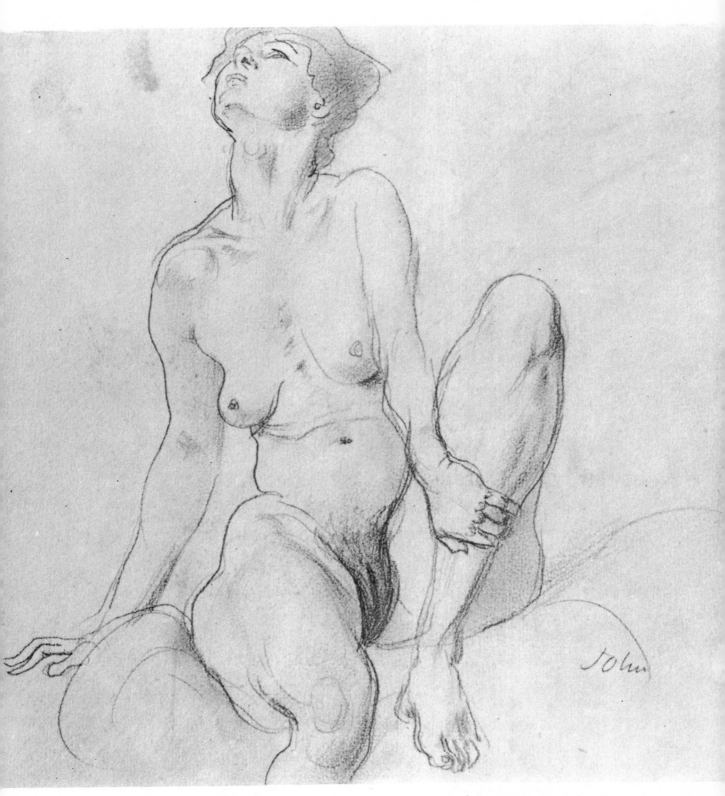

7. AUGUSTUS JOHN (1878-1961)

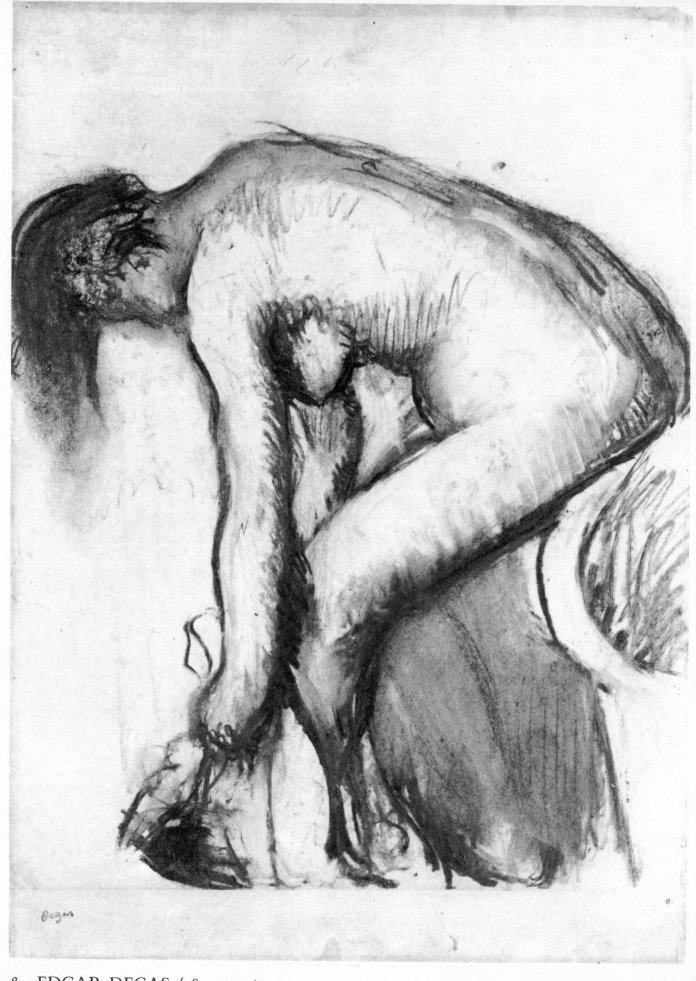

8. EDGAR DEGAS (1834-1917) *(S.P.A.D.E.M., Paris, 1965)*

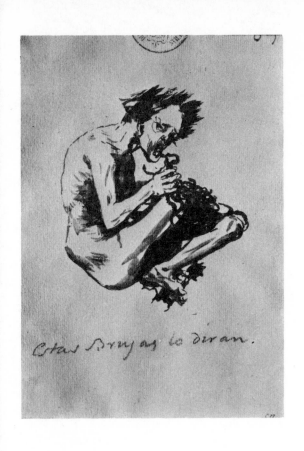

Estas Brujas lo diran.

9. FRANCISCO DE GOYA (1746–1828)

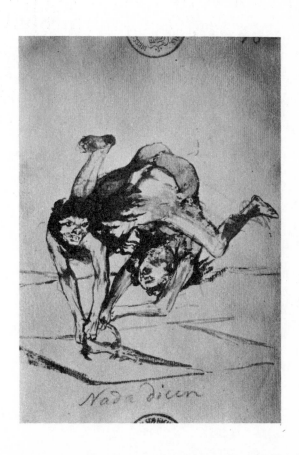

Nada dicen

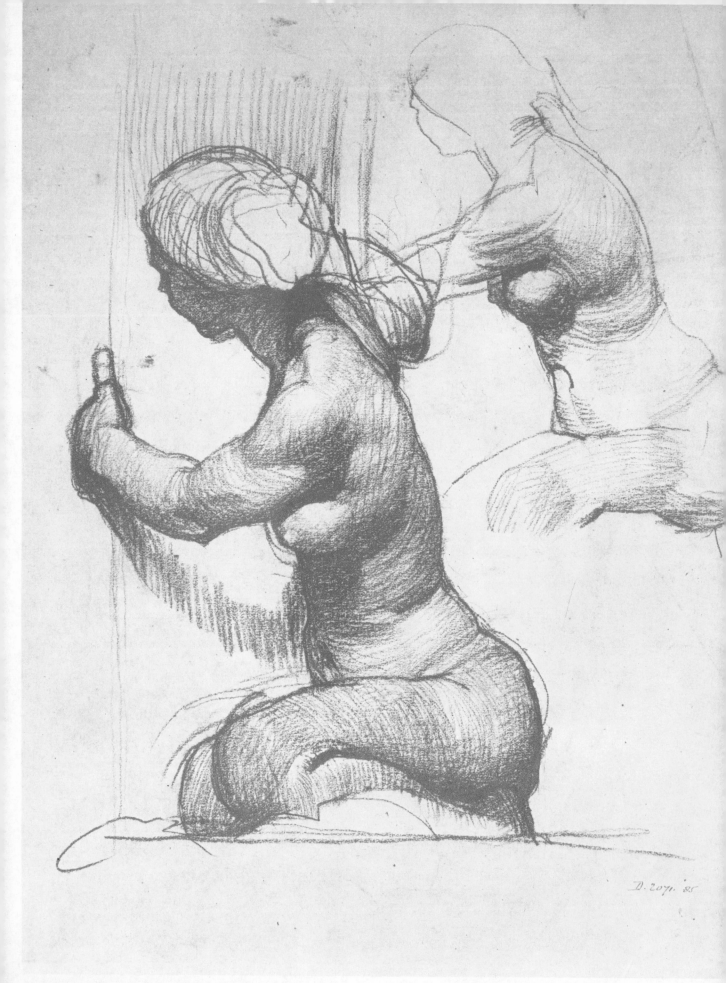

10. ALFRED STEVENS (1818–75)

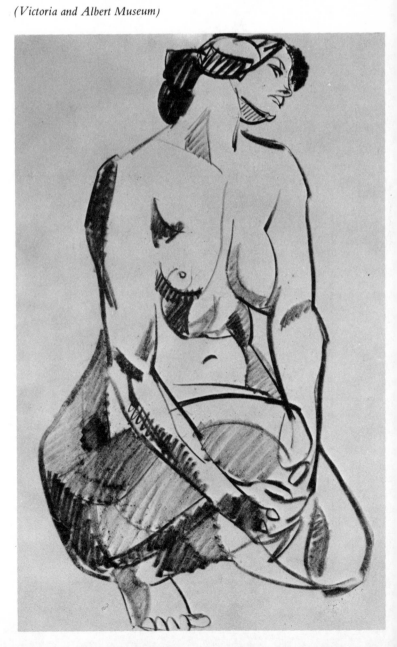

11. HENRI GAUDIER-BRZESKA (1891–1915)

(Victoria and Albert Museum)

YASUO KUNIYOSHI (1893–1953)

12. PETER BLAKE (1932–)

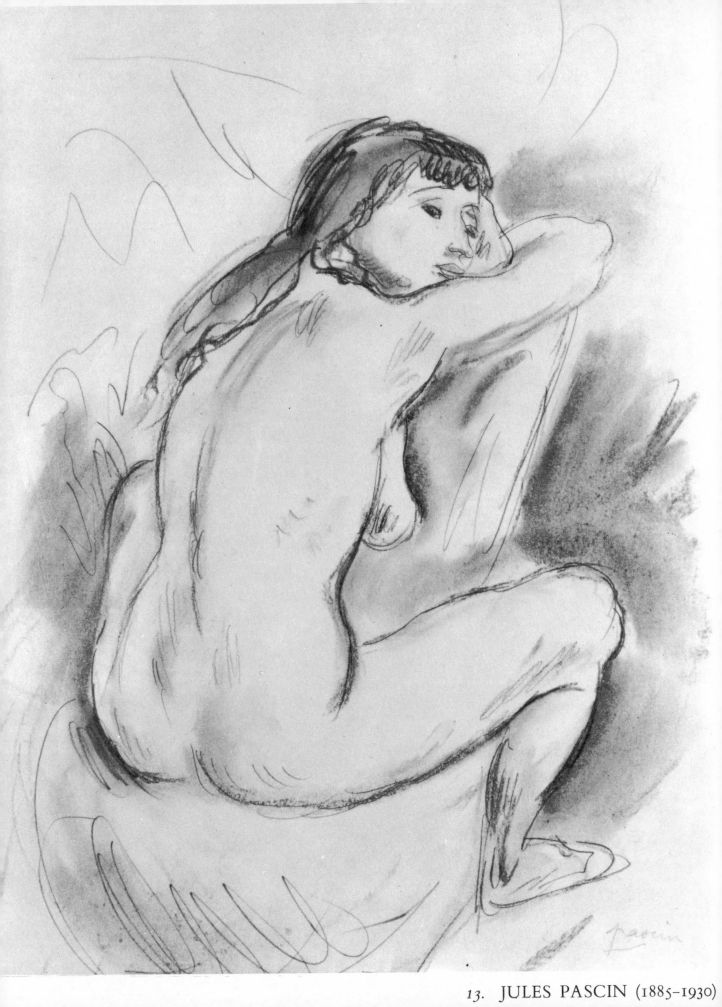

13. JULES PASCIN (1885-1930)

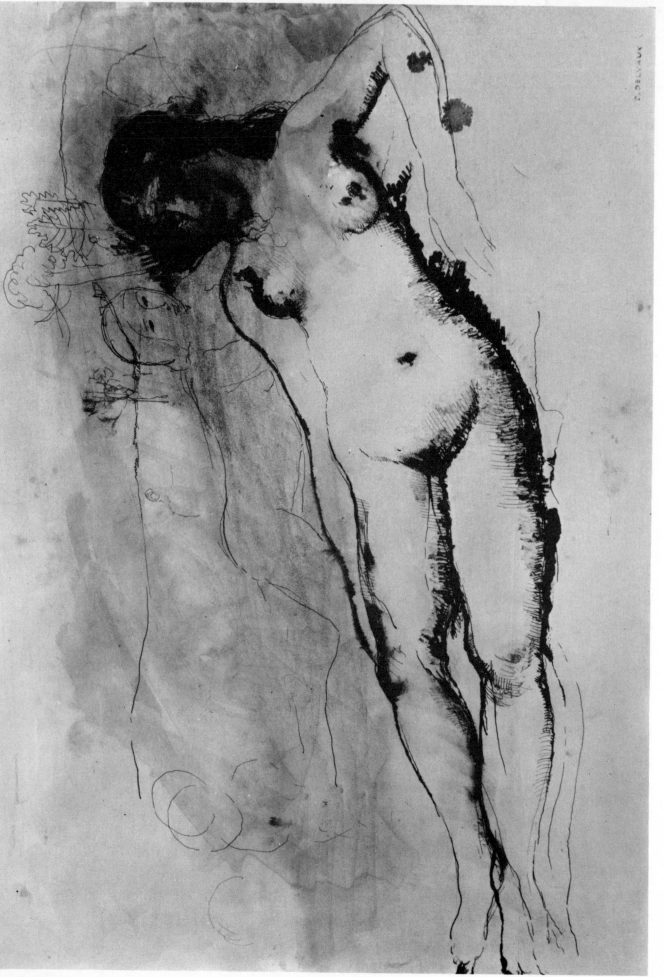

14. PAUL DELVAUX (1898–)

15. JULES PASCIN (1885–1930)

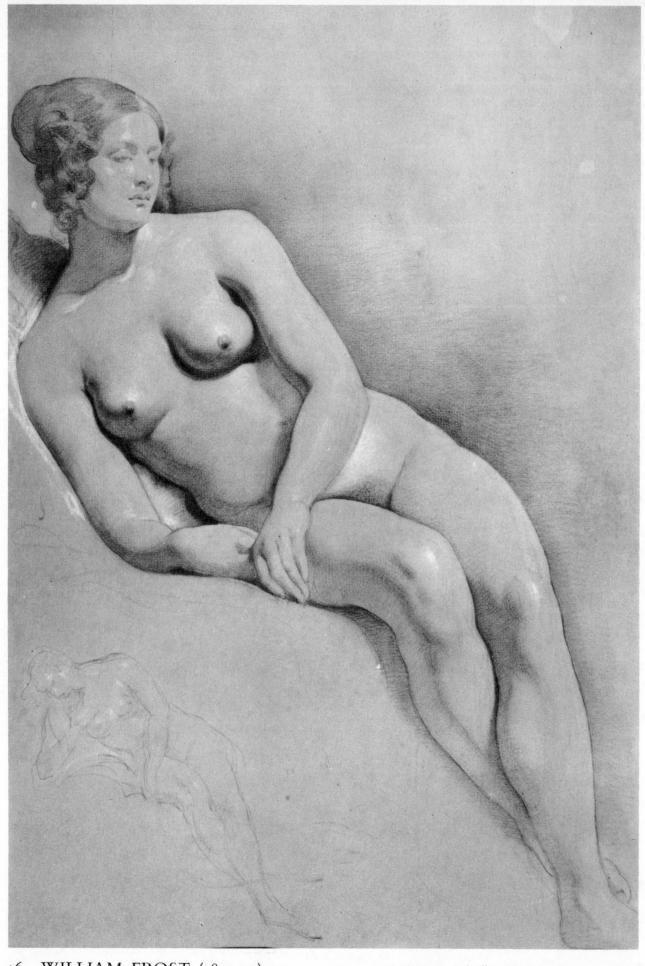

16. WILLIAM FROST (1810–77) (Victoria and Albert Museum. Crown copyright)

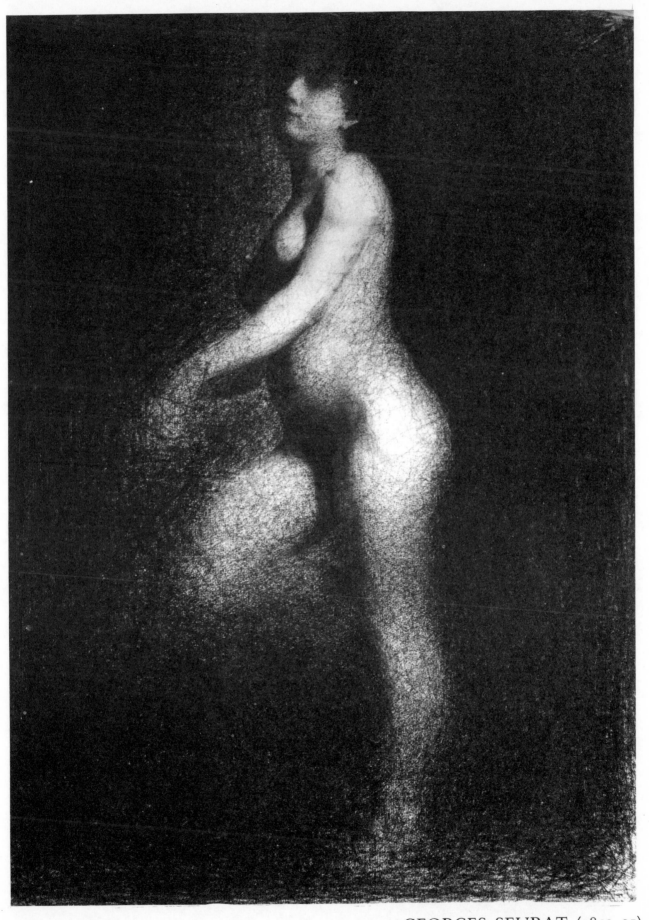

17. GEORGES SEURAT (1859-91)

18. GEORG GROSZ (1893–1959)

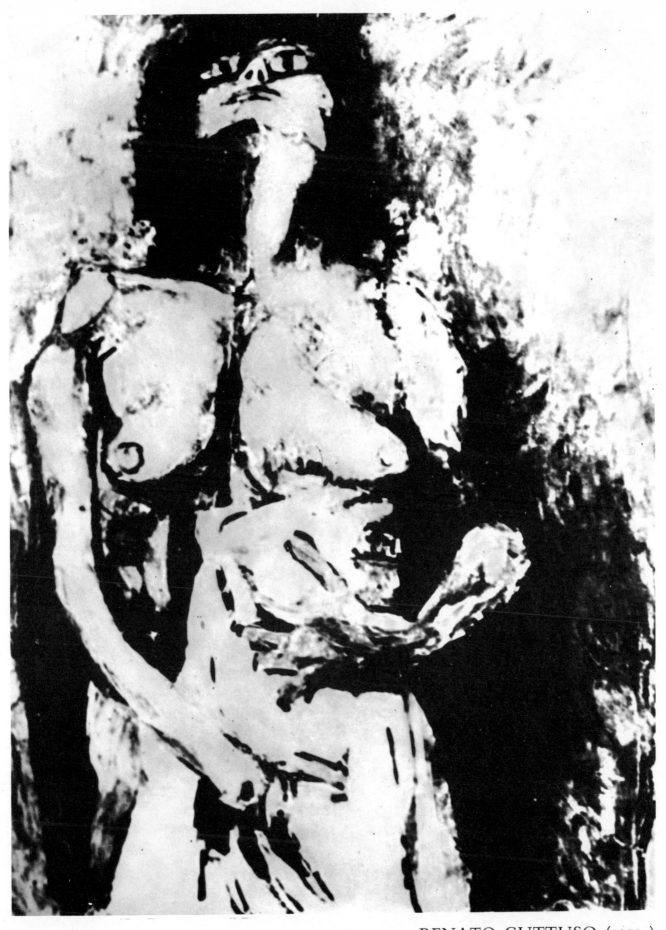

19. RENATO GUTTUSO (1912–)

(S.P.A.D.E.M., Paris, 1965

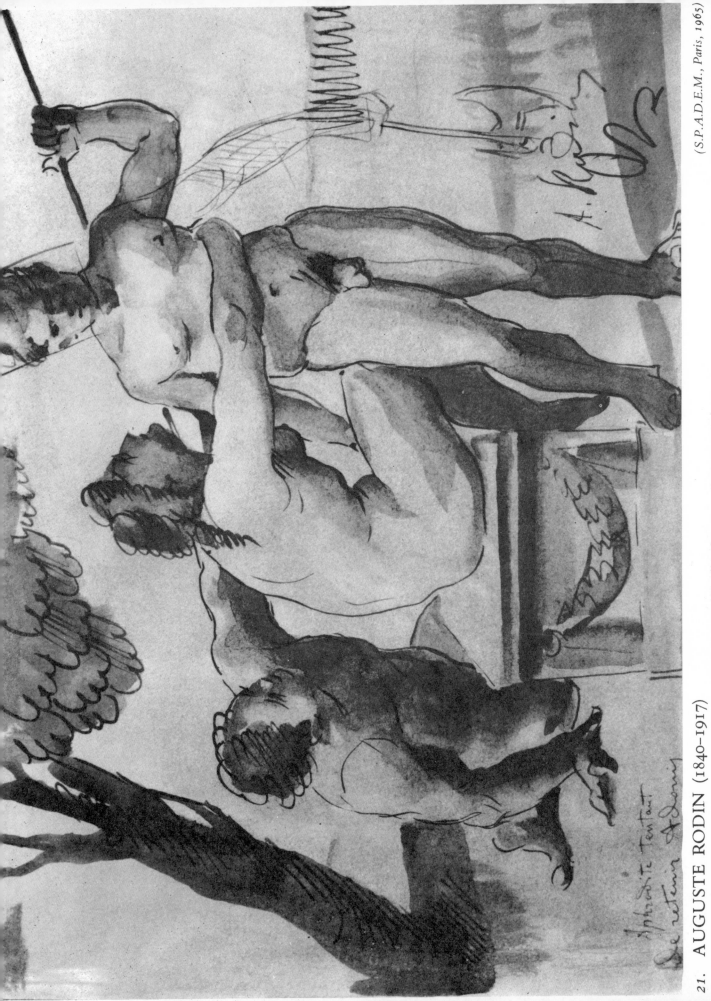

21. AUGUSTE RODIN (1840–1917)

22. ARISTIDE MAILLOL (1861–1944) *(S.P.A.D.E.M., Paris, 1965)*

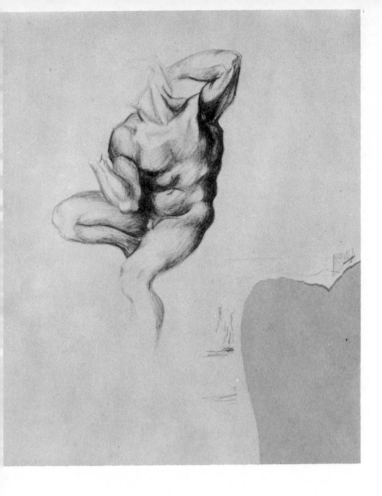

23. JACKSON POLLOCK (1912–56)

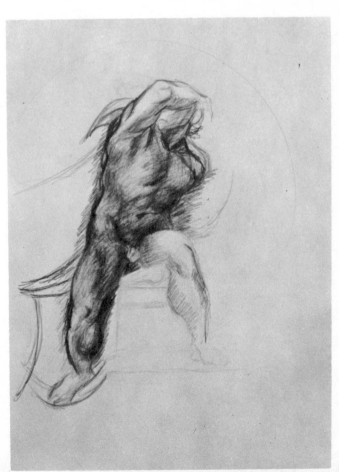

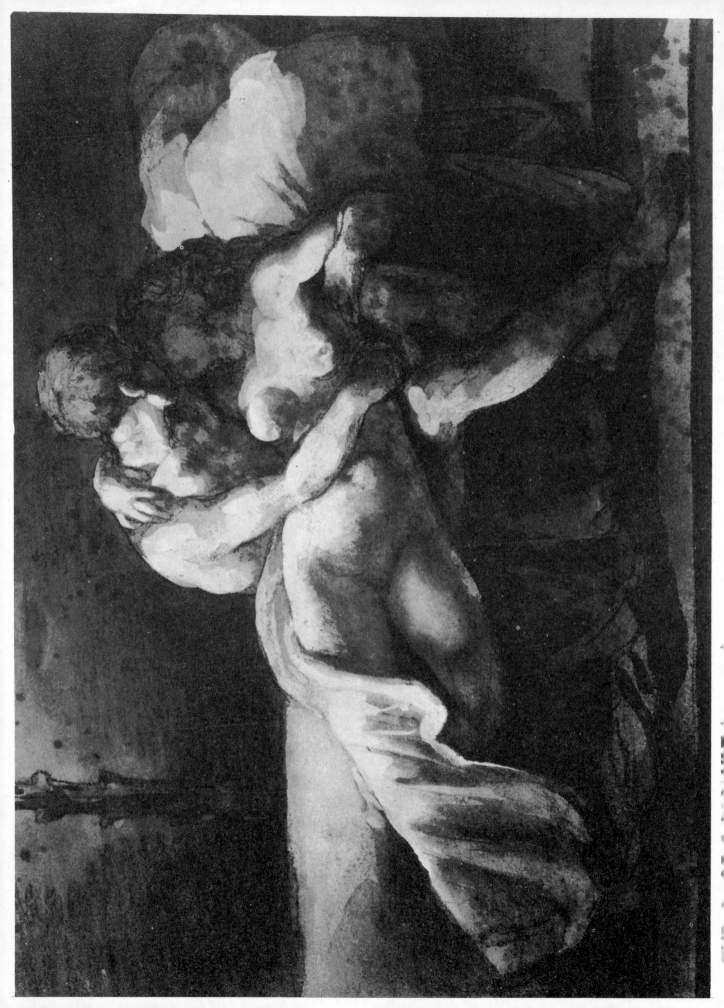

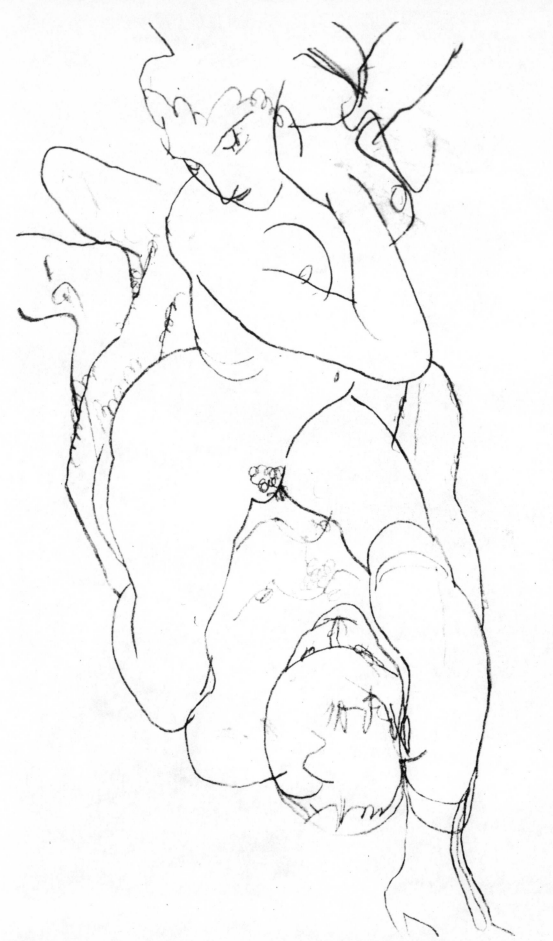

25. EGON SCHIELE (1890–1918)

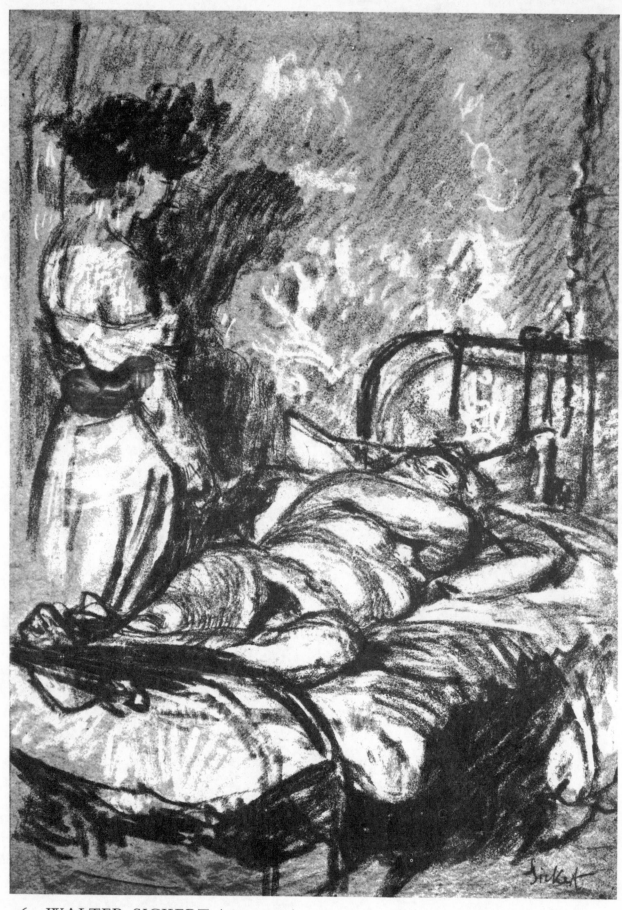

26. WALTER SICKERT (1860–1942)

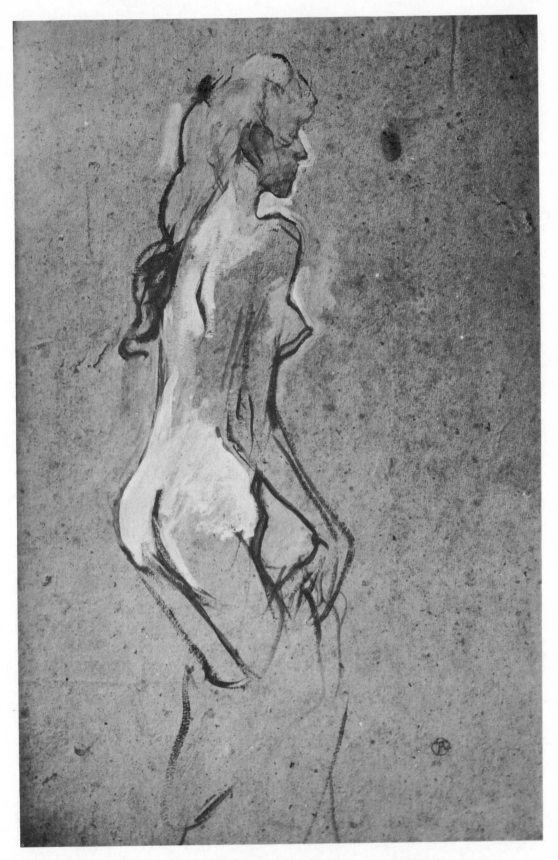

27. HENRI DE TOULOUSE-LAUTREC (1864-1901)

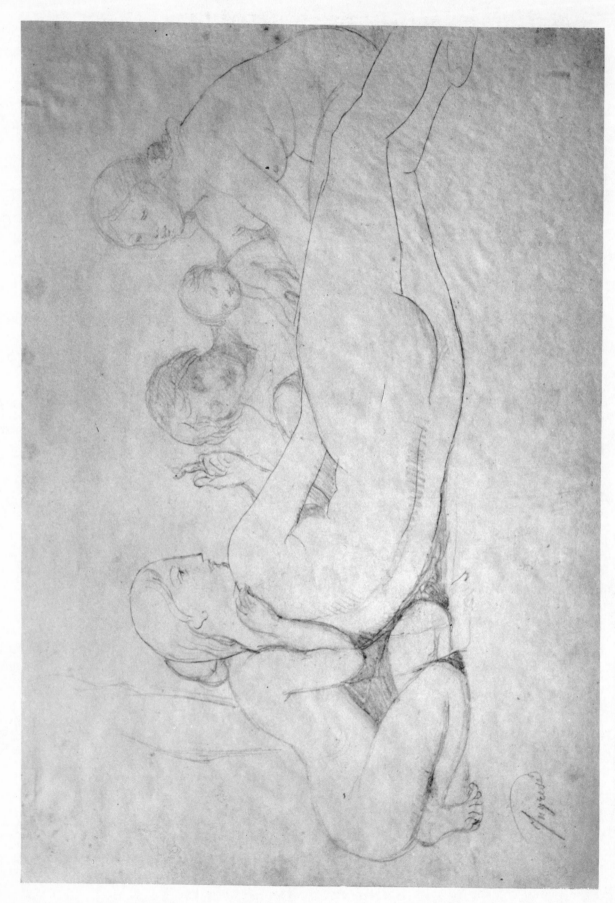

28. DOMINIQUE INGRES (1780–1867)

29. ADOLF MENZEL (1815–1905)

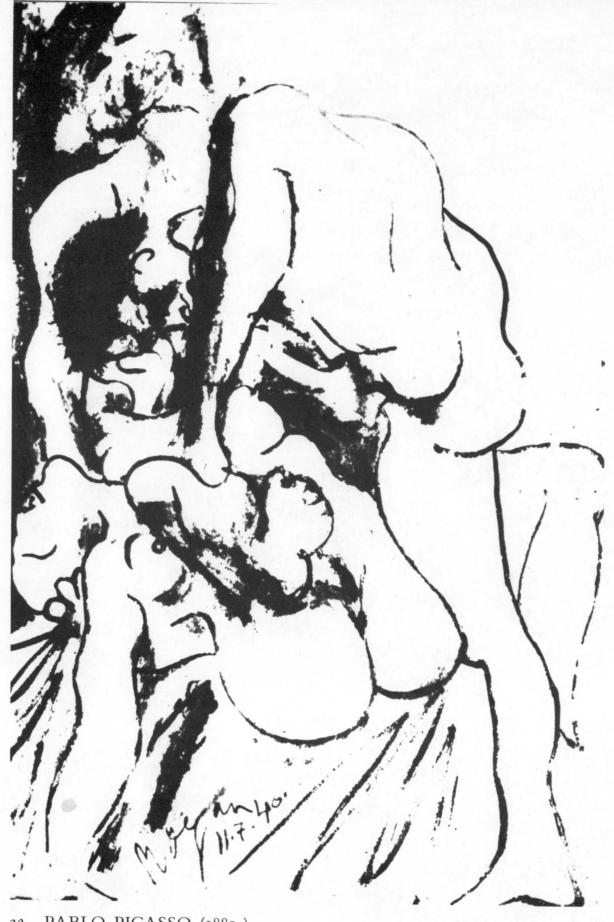

30. PABLO PICASSO (1881-)

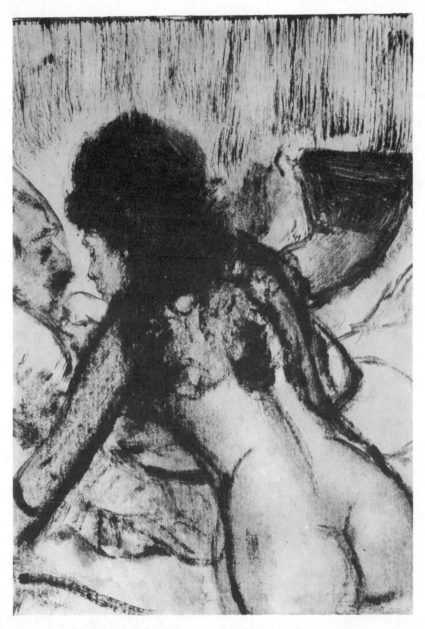

31. EDGAR DEGAS (1834–1917) *(S.P.A.D.E.M., Paris, 1965)*

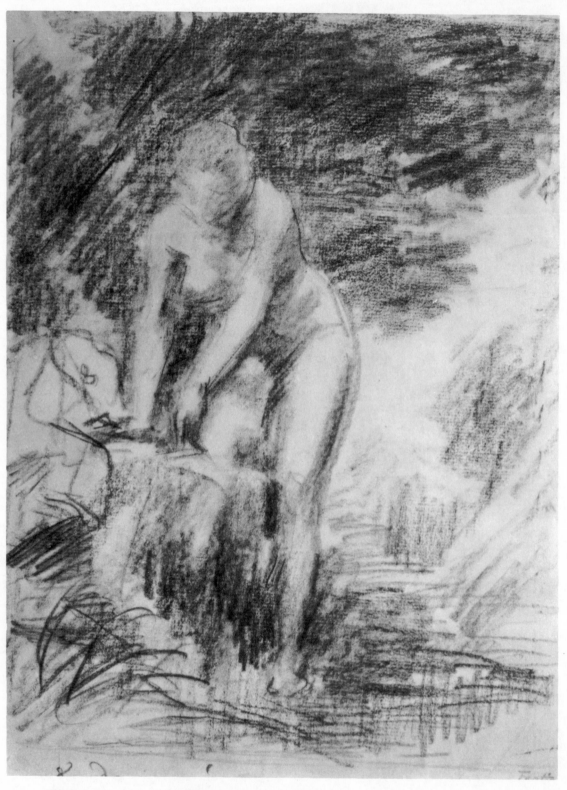

32. THEODORE FANTIN-LATOUR (1836-1904) *(S.P.A.D.E.M., Paris, 1965)*

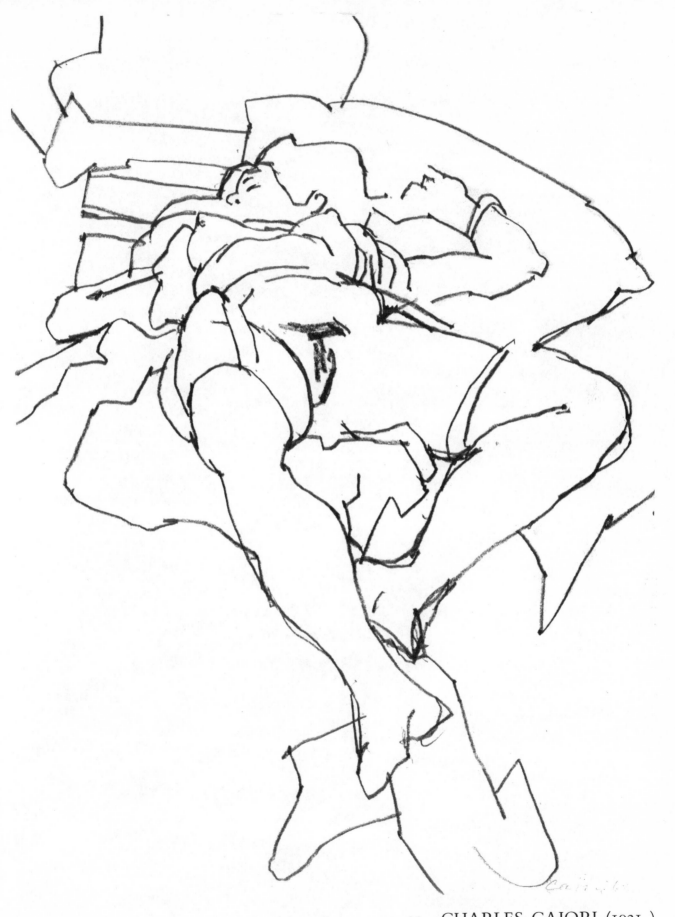

33. CHARLES CAJORI (1921–)

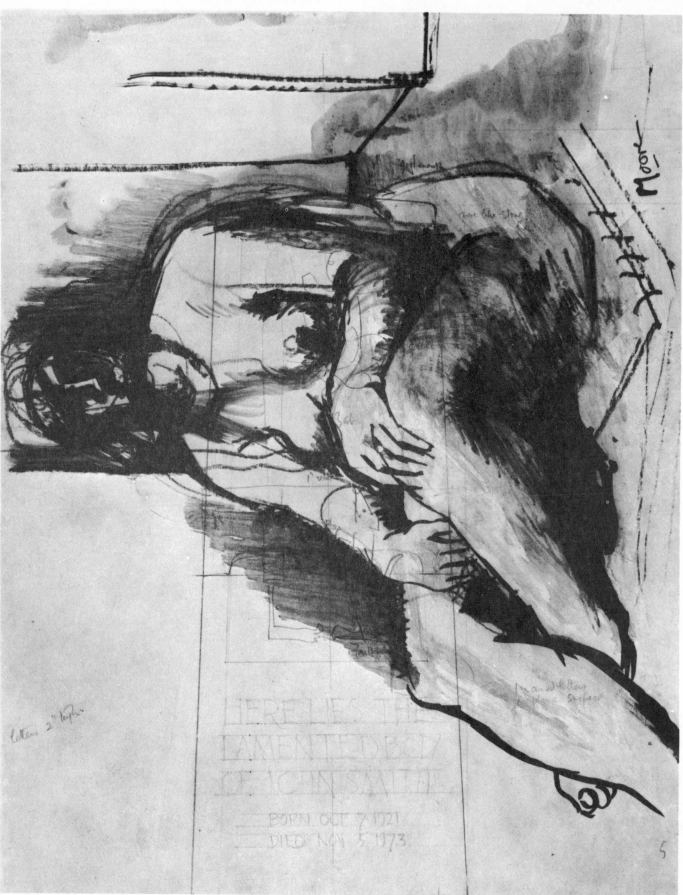

HERE LIES THE
LAMENTED BODY
OF JOHN SMITH

BORN OCT 7 1921
DIED NOV 5 1973

35. JACOB EPSTEIN (1880–1959)

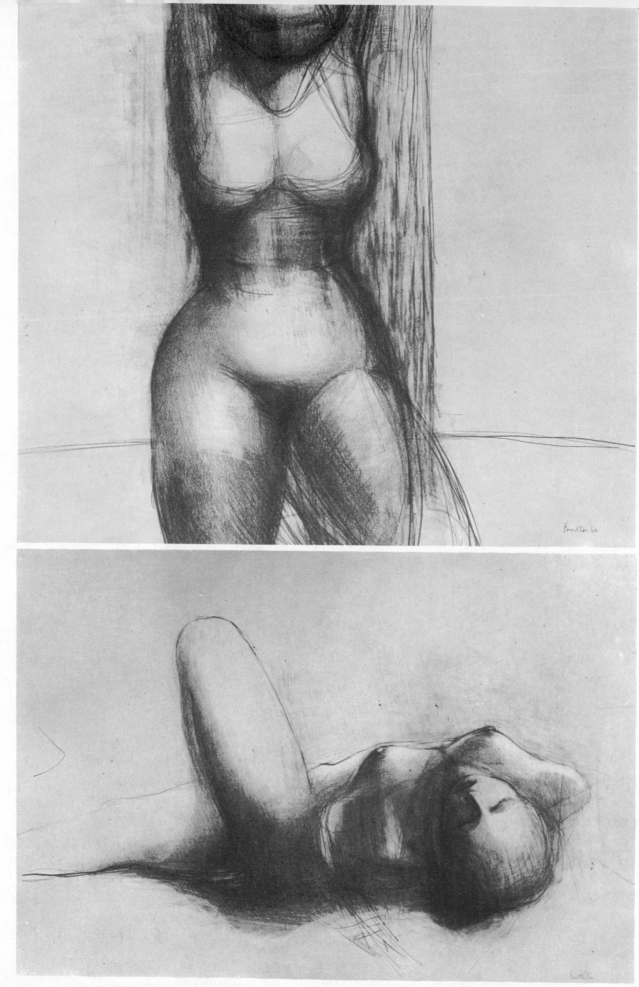

36. REG BUTLER (1913-)

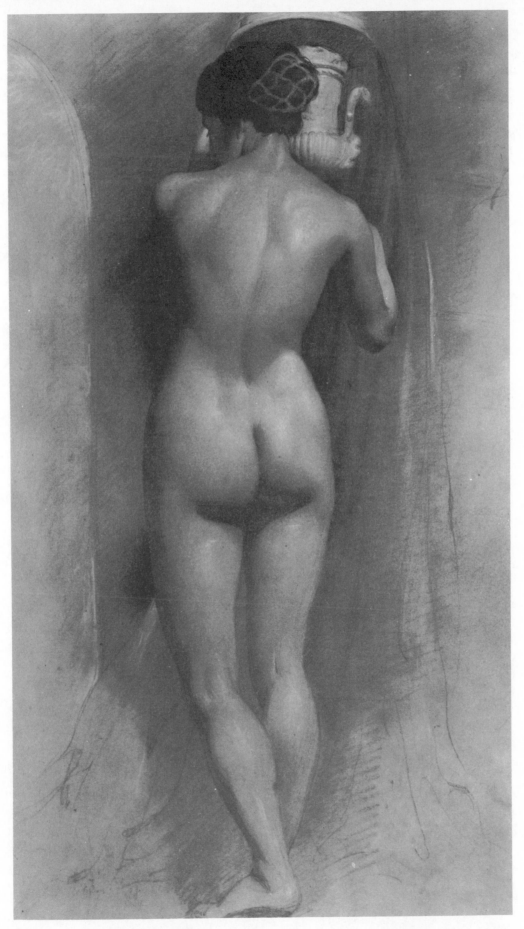

37. WILLIAM ETTY (1787–1849)

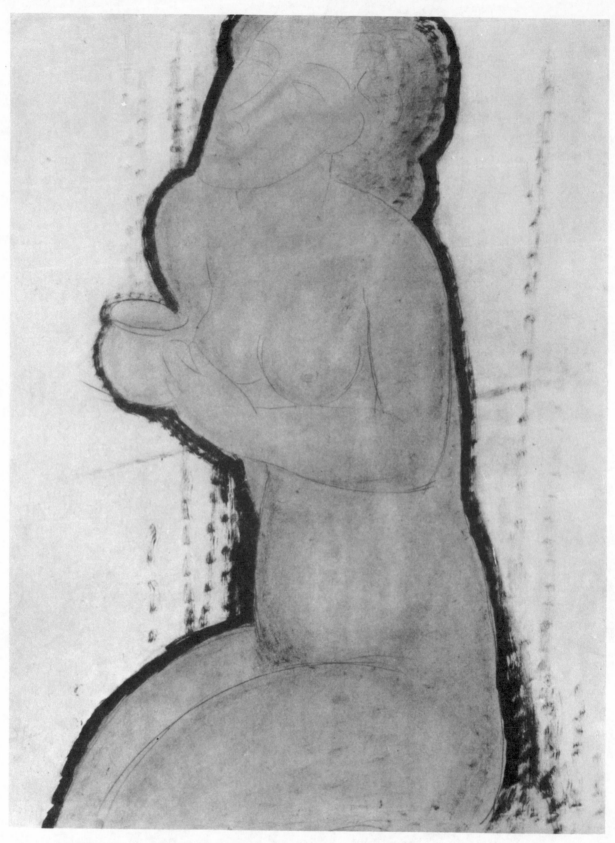

38. AMEDEO MODIGLIÁNI· (1884–1920)

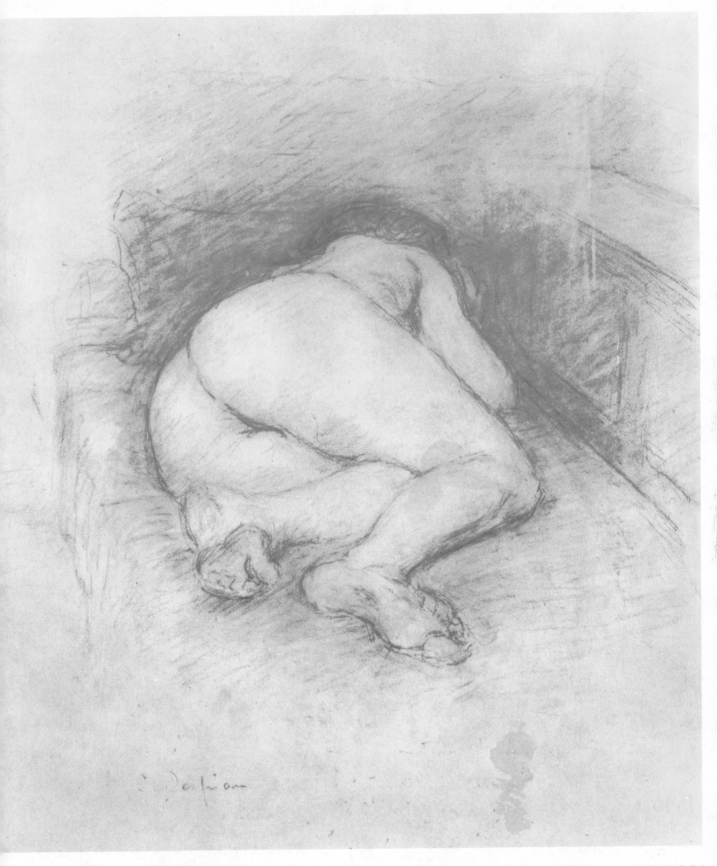

39. CHARLES DESPIAU (1874–1946)

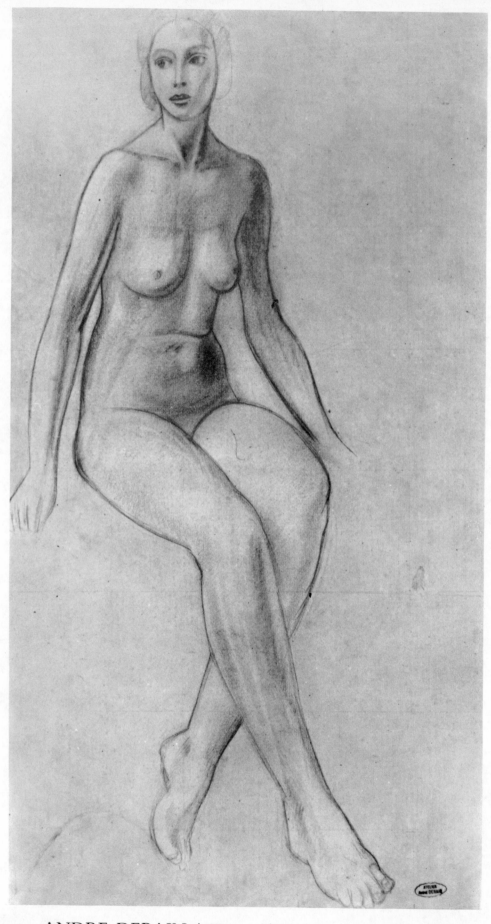

40. ANDRE DERAIN (1880–1954)

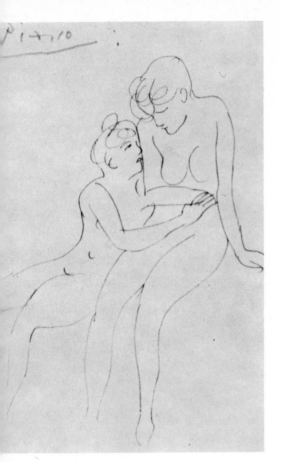

41. PABLO PICASSO (1881–) *(S.P.A.D.E.M., Paris, 1965)*

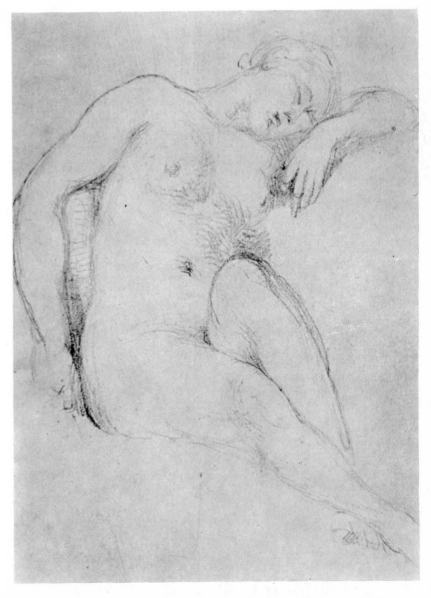

WILLIAM ETTY (1787–1849)

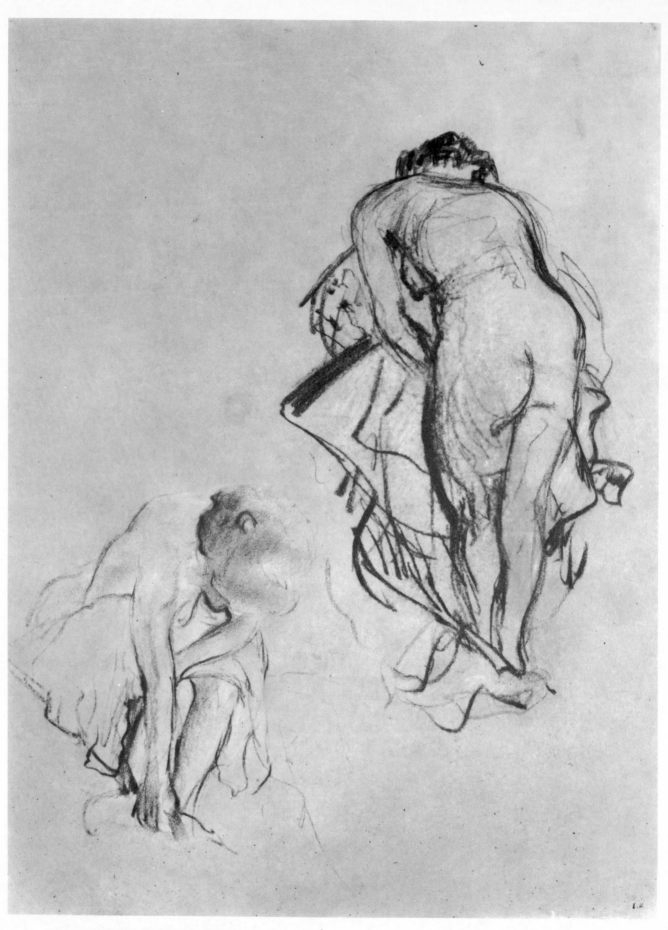

42. EDOUARD VUILLARD (1868–1940) (S.P.A.D.E.M., Paris, 1965)

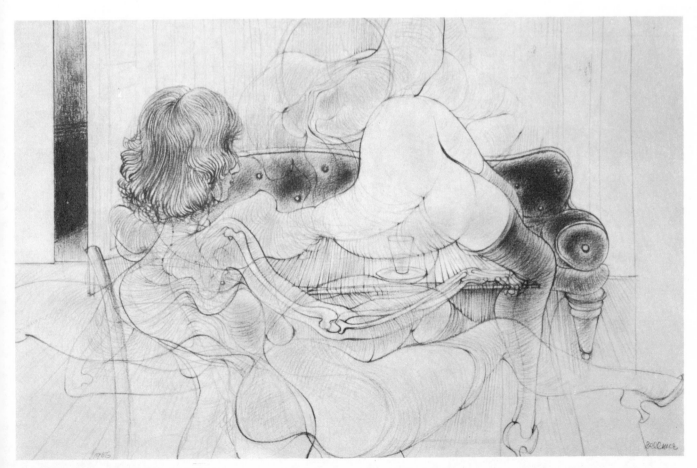

HANS BELLMER (1902–)

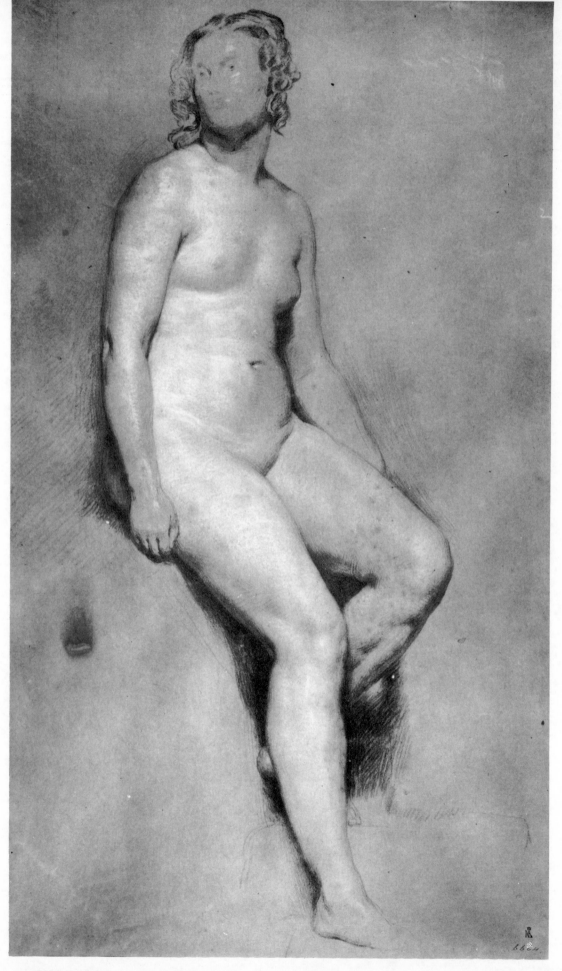

44. WILLIAM MULREADY (1786–1883) *(Victoria and Albert Museum. Crown copyright)*

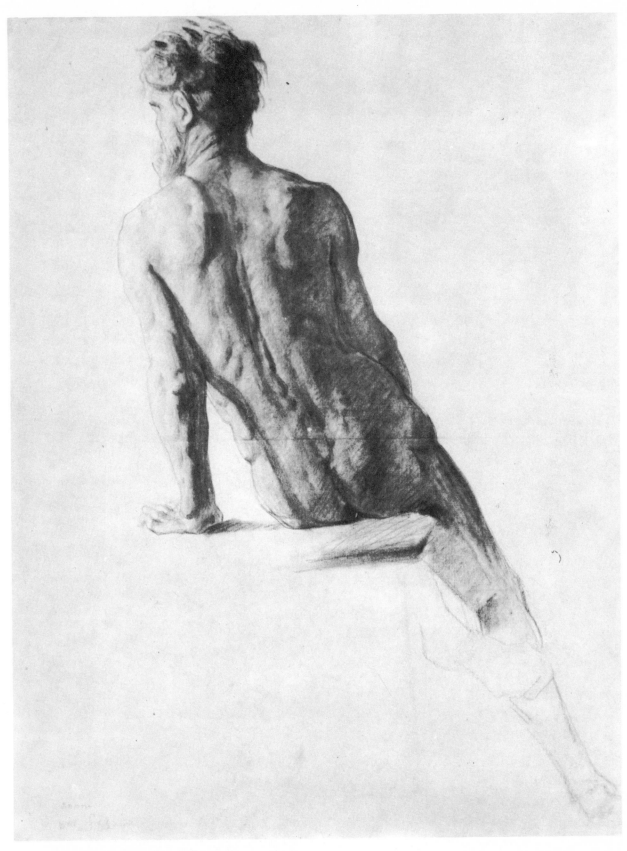

45. PAUL CEZANNE (1839–1906) *(S.P.A.D.E.M., Paris, 1956)*

46. AVINASH CHANDRA (1931–)

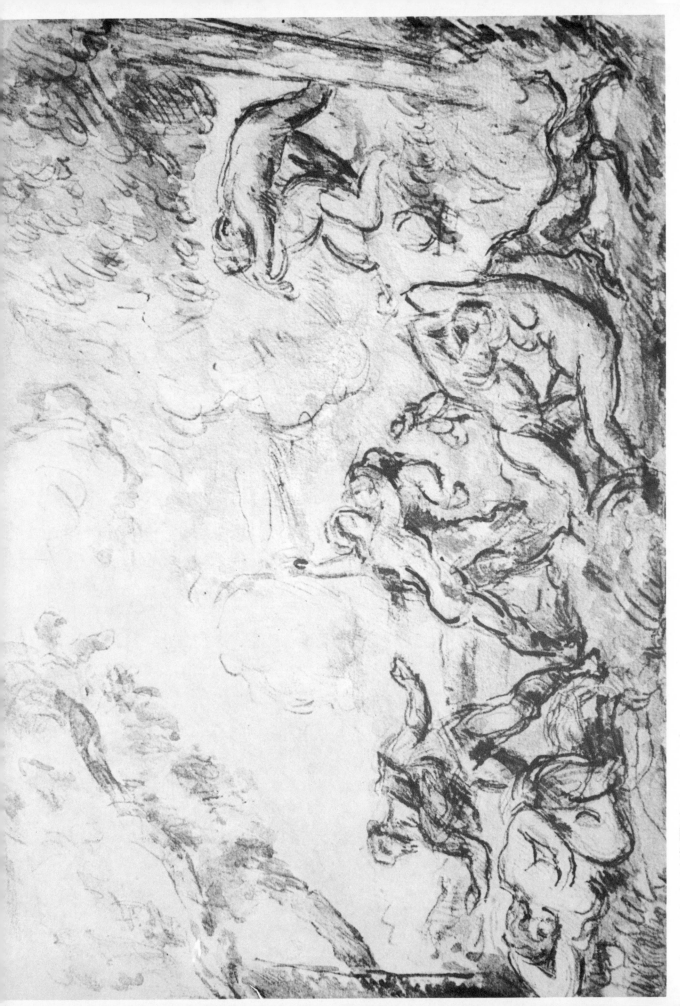

47. PAUL CEZANNE (1839–1906)

48. PAUL KLEE (1879–1940)

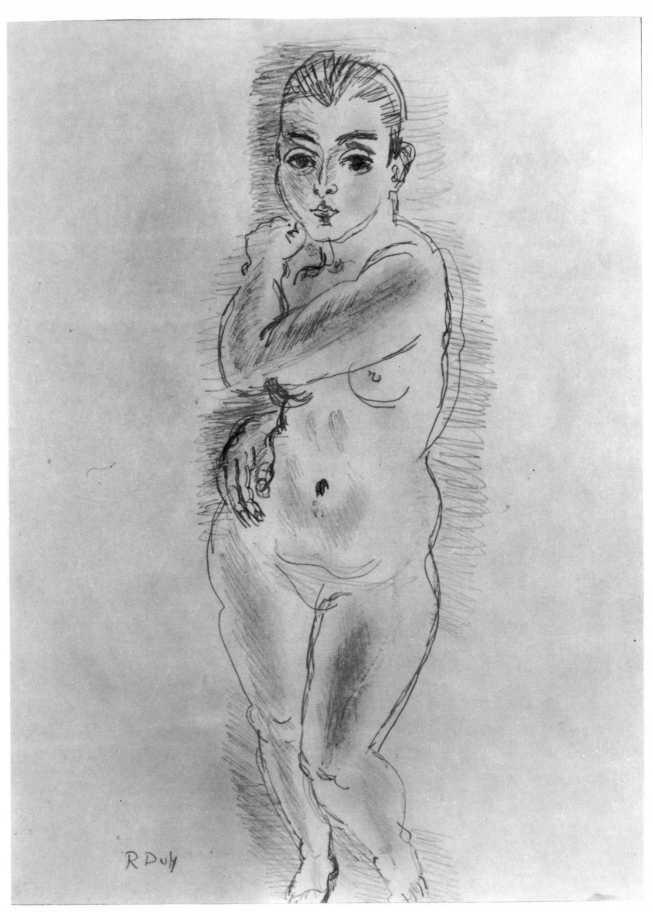

49. RAOUL DUFY (1877–1953) (S.P.A.D.E.M., Paris, 1965)

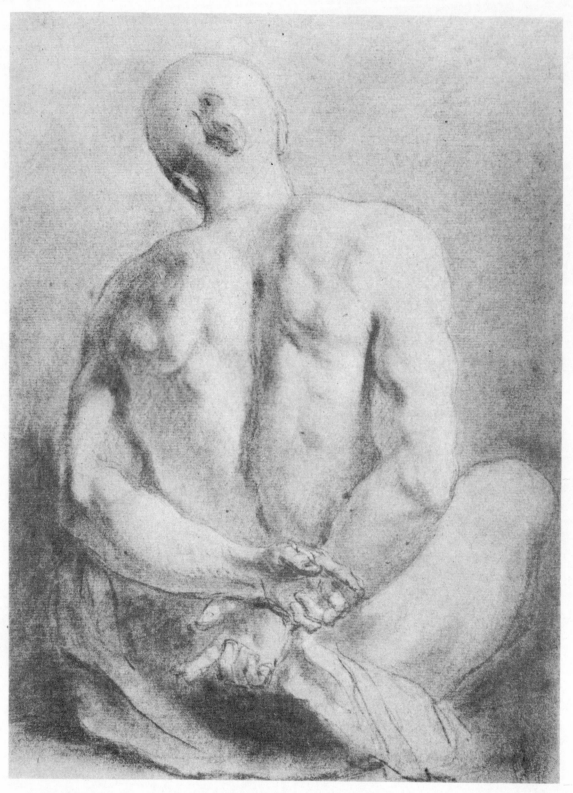

50. WILLIAM HOGARTH (1697–1764)

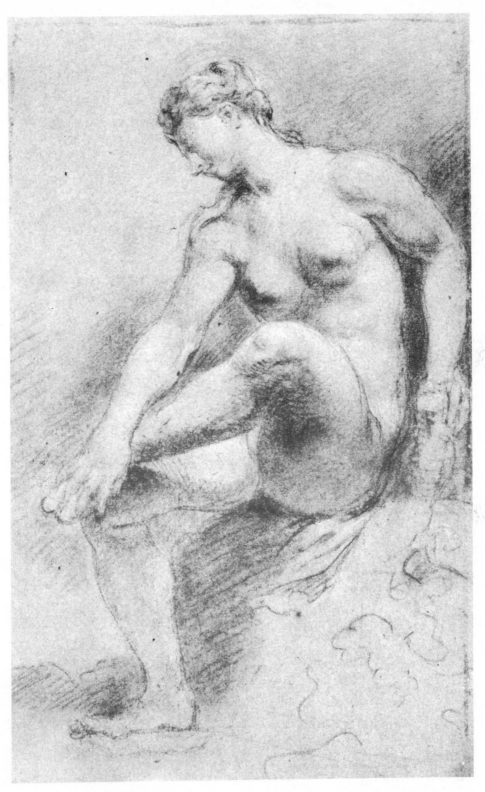

51. WILLIAM HOGARTH (1697–1764)

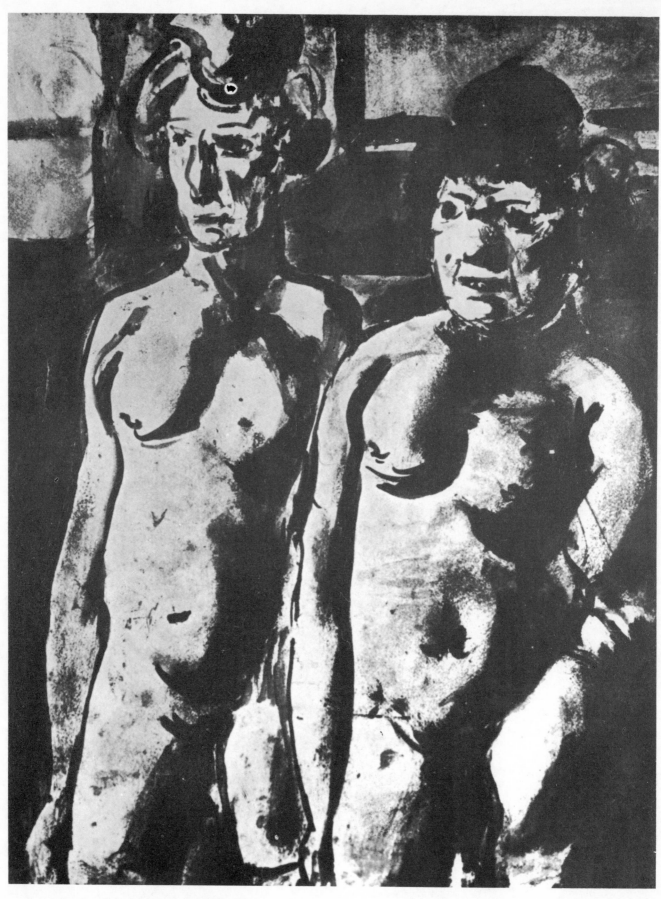

52. GEORGES ROUAULT (1871-)

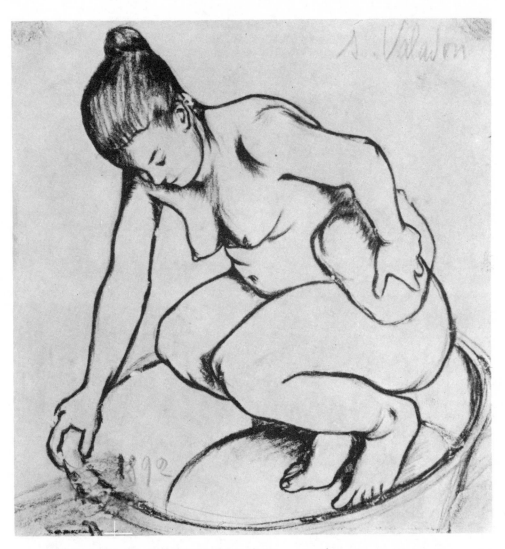

53. SUZANNE VALADON (1865-1938) *(S.P.A.D.E.M., Paris, 1965)*

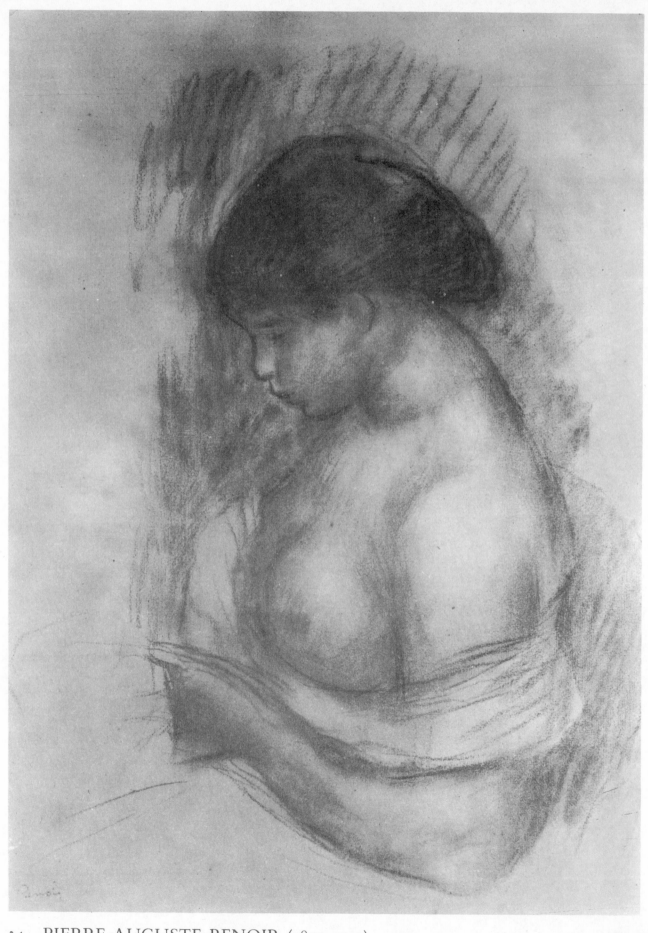

54. PIERRE-AUGUSTE RENOIR (1841–1919) (S.P.A.D.E.M., Paris, 1965)

55. PIERRE BONNARD (1867–1947)

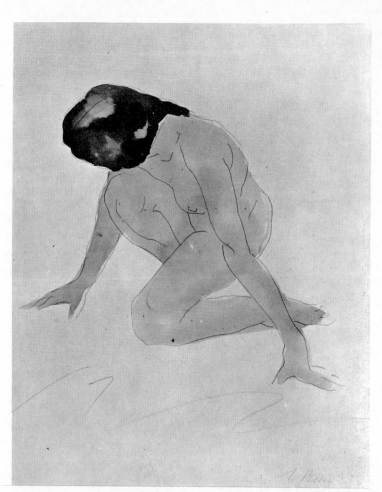

56. AUGUSTE RODIN (1840–19

(S.P.A.D.E.M., Paris, 1965)
(Victoria and Albert Museum)

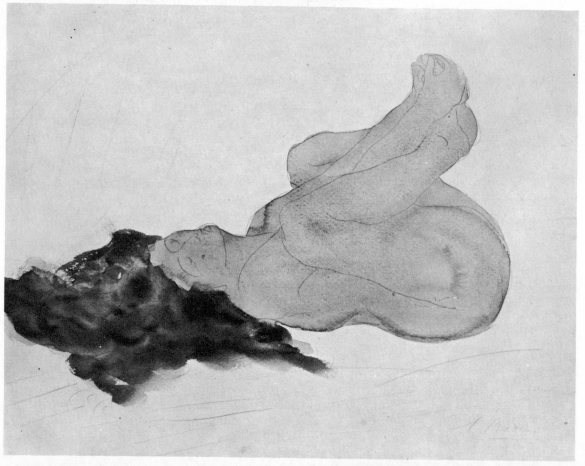

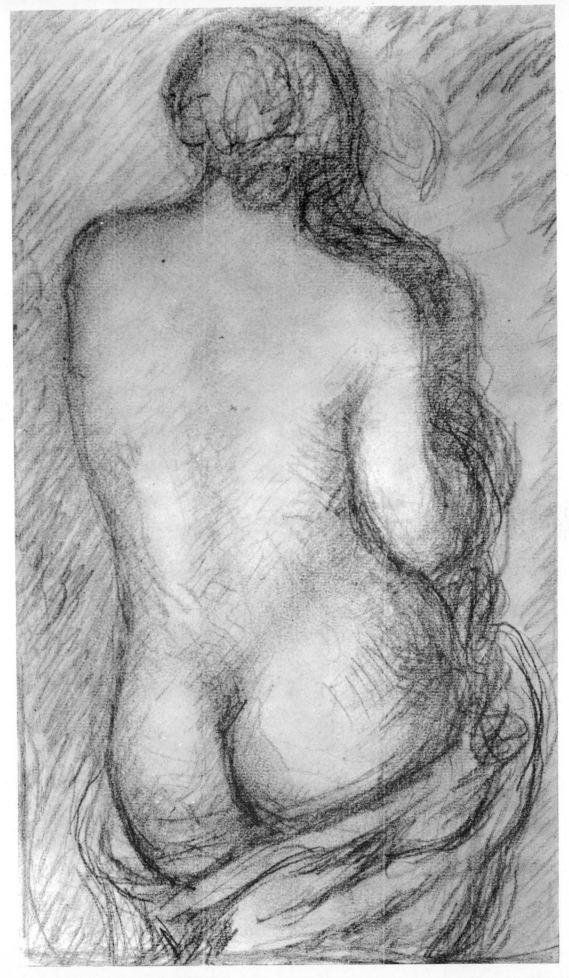

57. ARISTIDE MAILLOL (1861–1944) *(S.P.A.D.E.M., Paris, 1965)*

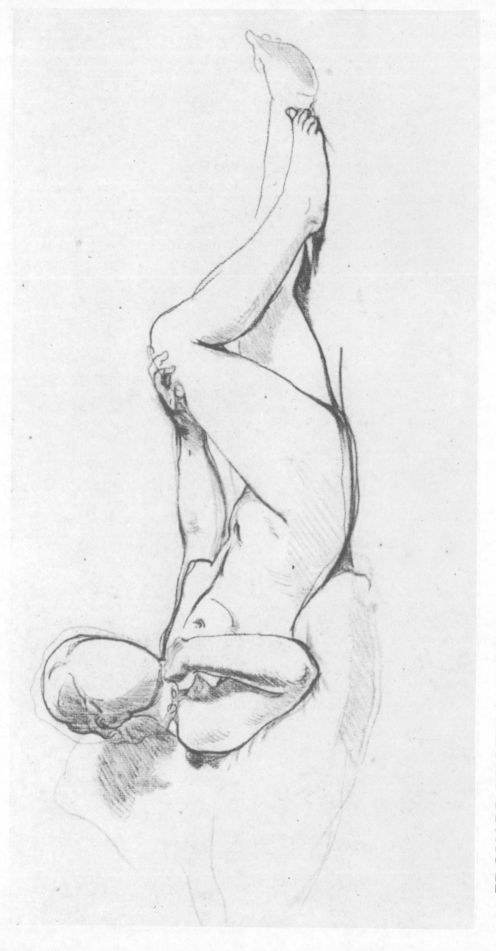

58. EDOUARD MANET (1832–83)

(Musée du Louvre)

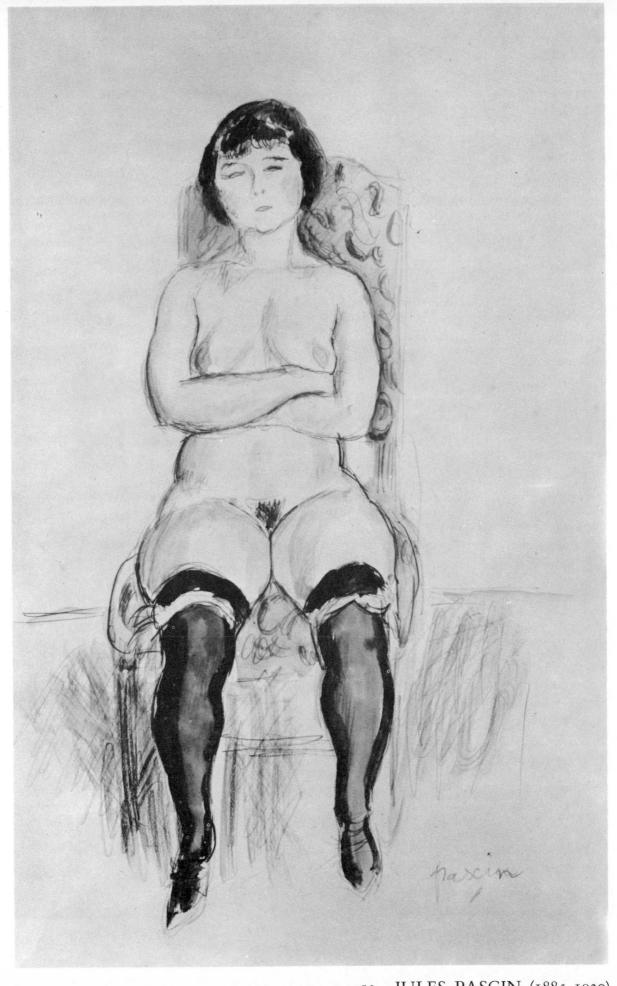

59. JULES PASCIN (1885-1930)

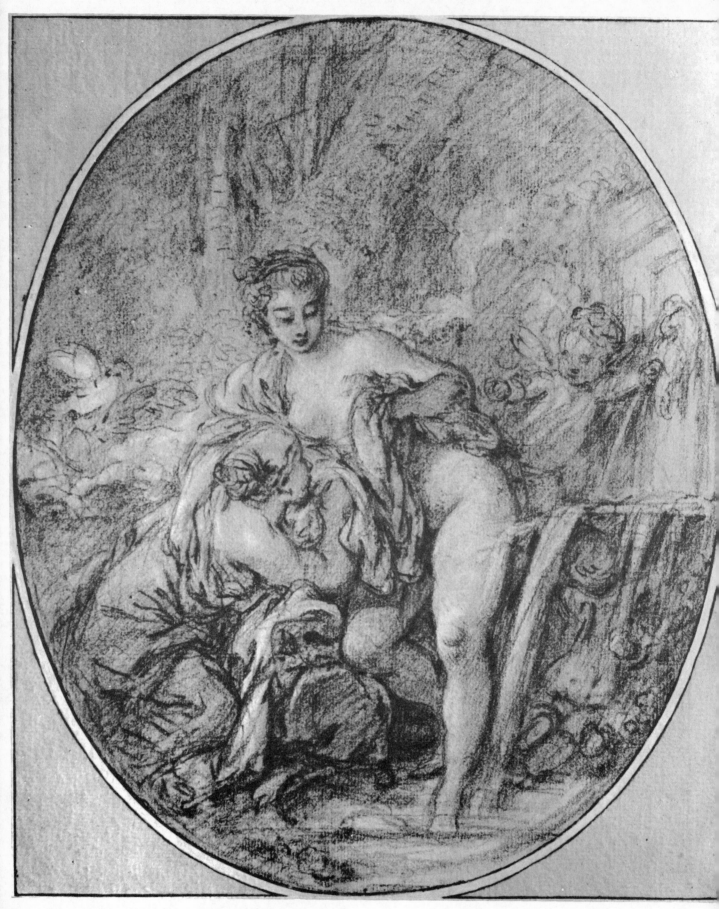

60. FRANCOIS BOUCHER (1703–70)

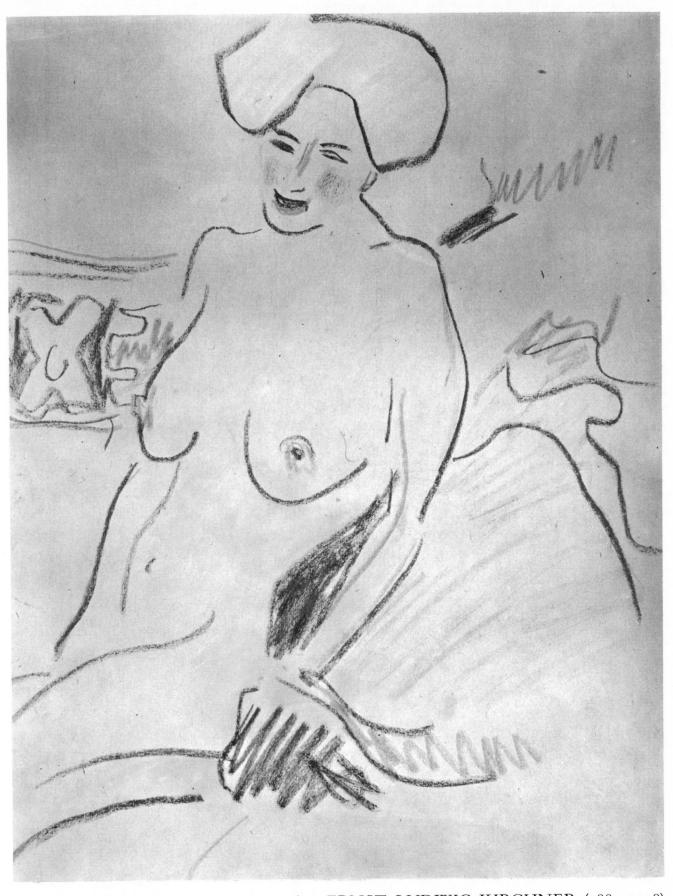

61. ERNST LUDWIG KIRCHNER (1880–1938)

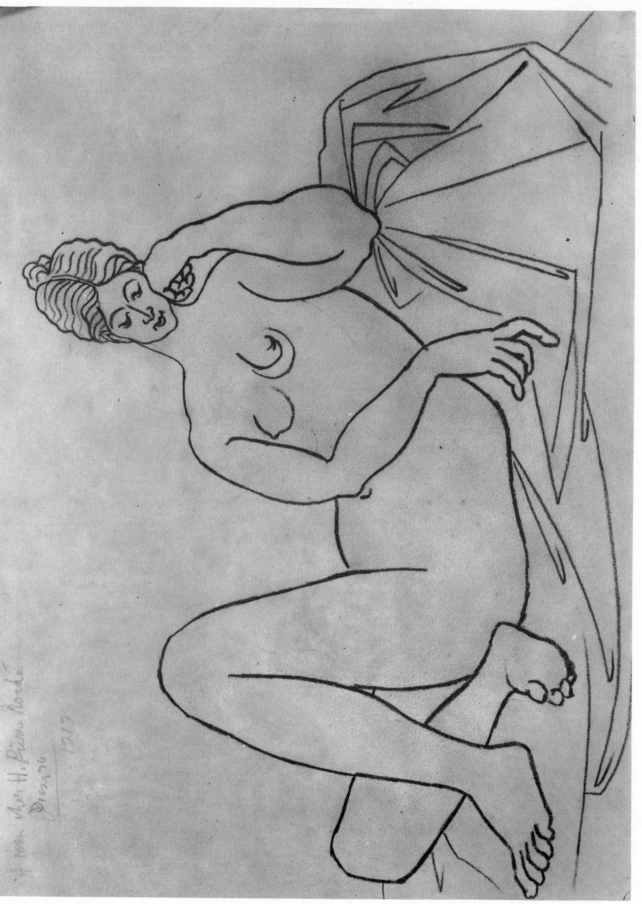

62. PABLO PICASSO (1881–)

(S.P.A.D.E.M., Paris, 1965)

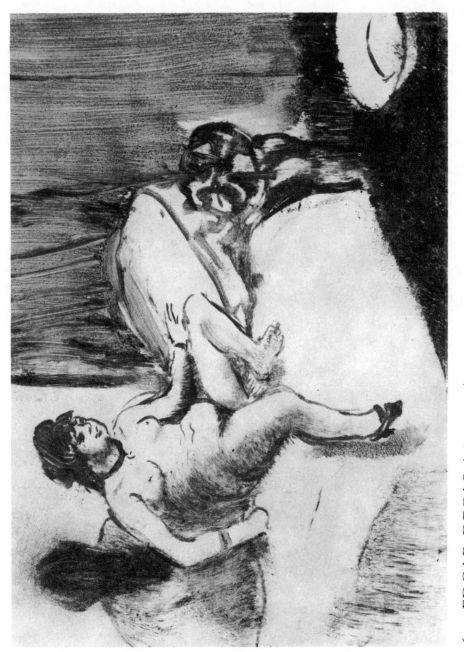

63. EDGAR DEGAS (1834–1917)

(S.P.A.D.E.M., Paris, 1965)

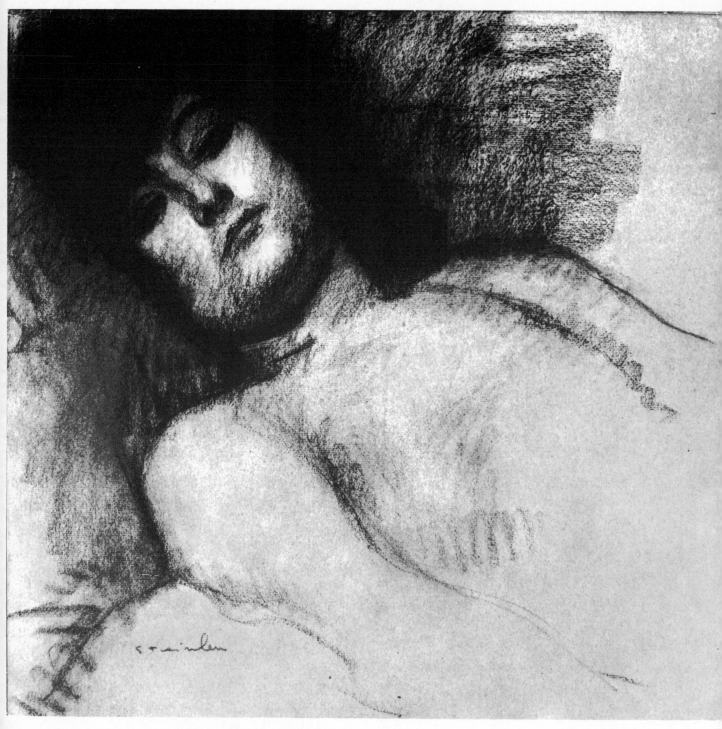

64. THEOPHILE-ALEXANDRE STEINLEN (1859–1923)

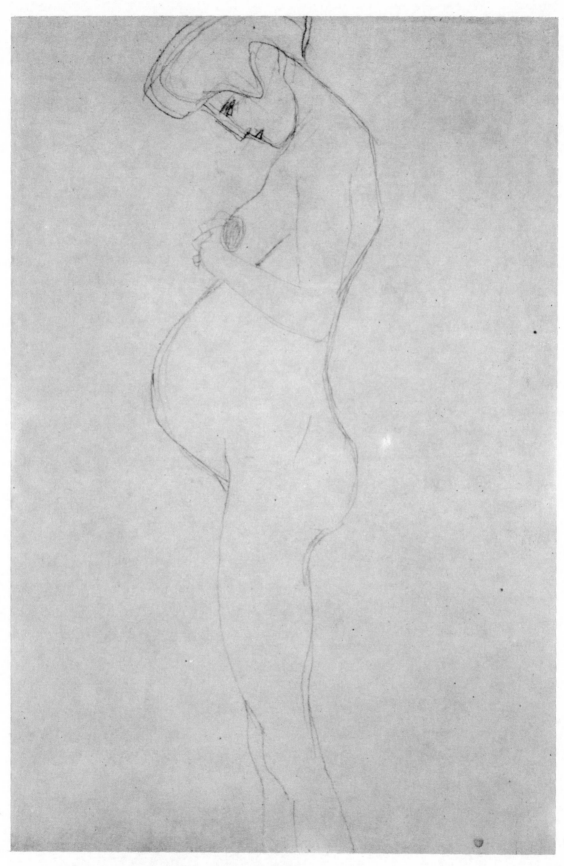

65. GUSTAVE KLIMT (1862–1918)

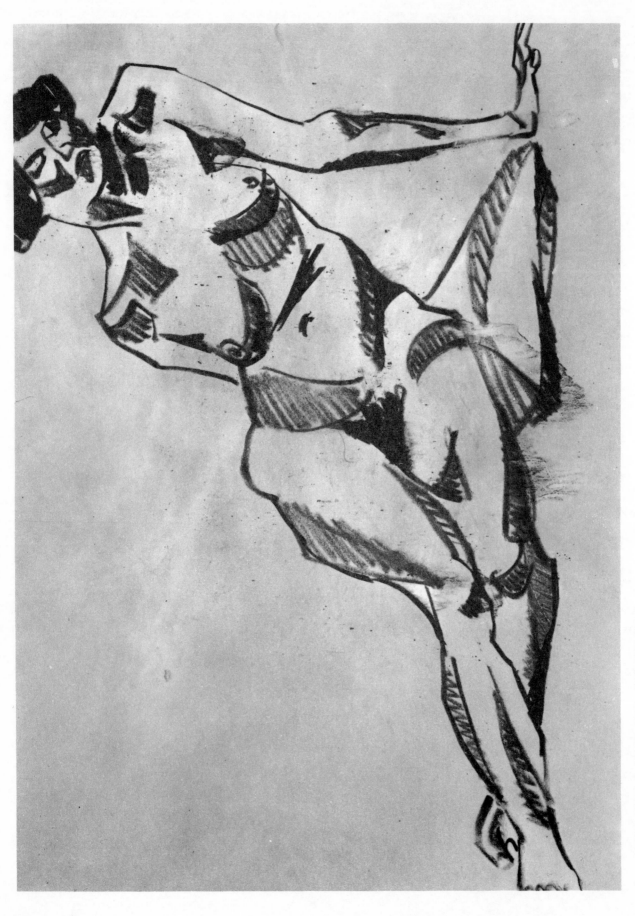

66. HENRI GAUDIER-BRZESKA (1891–1915) *(Victoria and Albert Museum)*

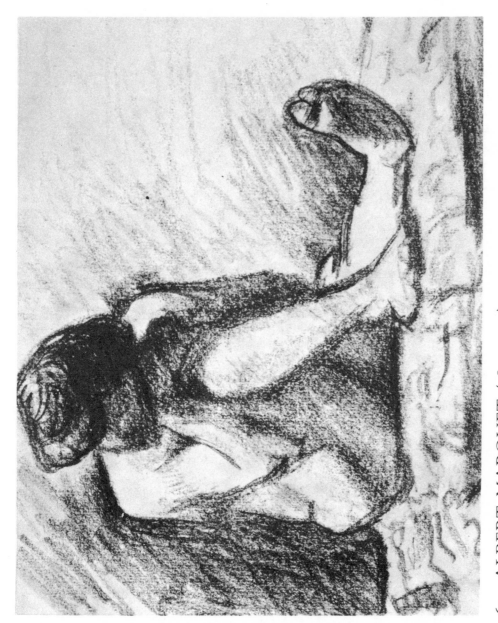

67. ALBERT MARQUET (1875–1947)

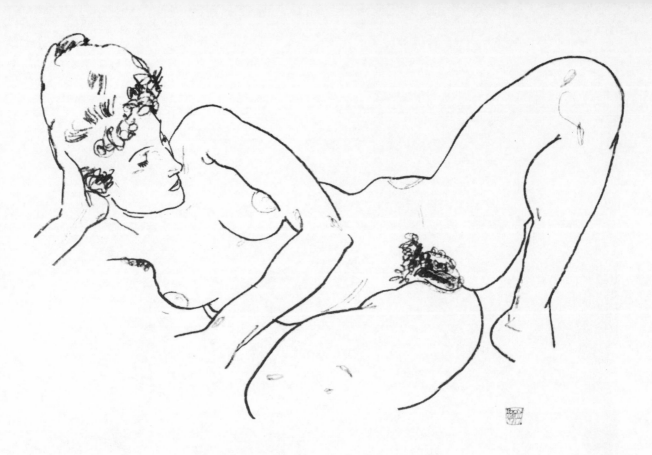

68. EGON SCHIELE (1890–1918)

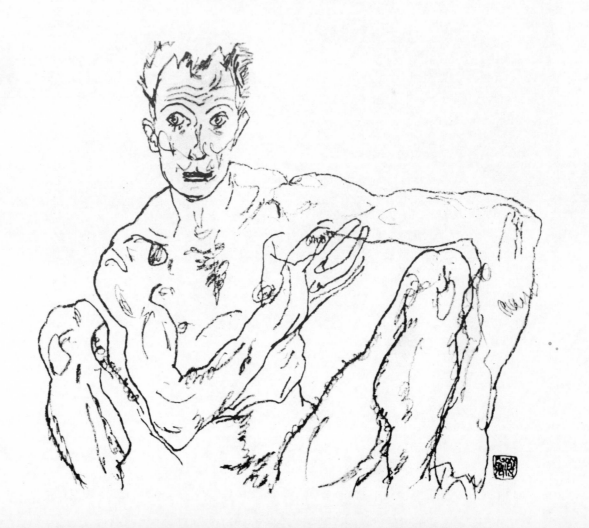

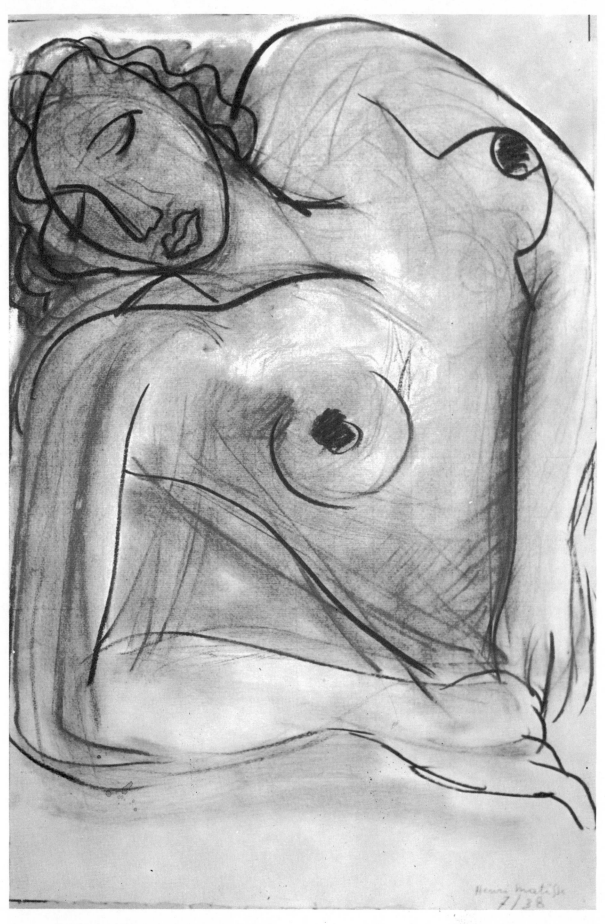

69. HENRI MATISSE (1869–1954) *(S.P.A.D.E.M., Paris, 1965)*

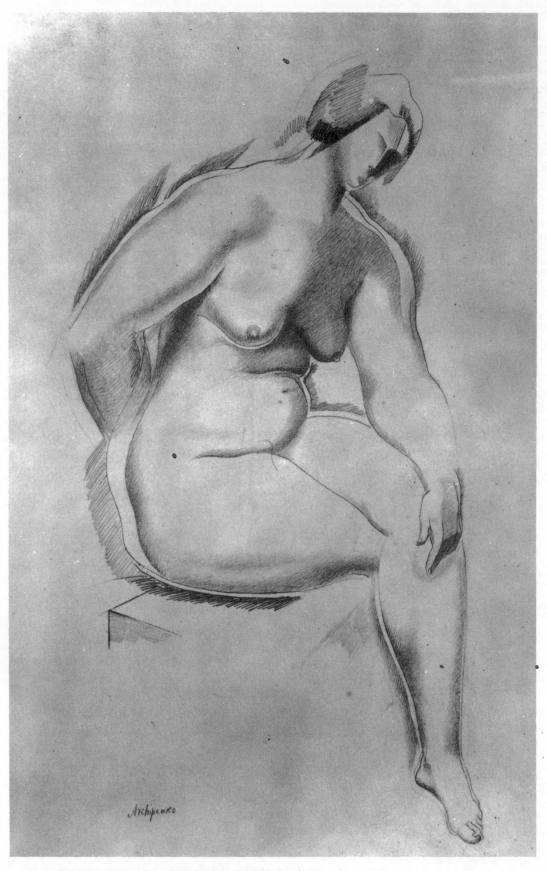

70. ALEXANDER ARCHIPENKO (1887–)

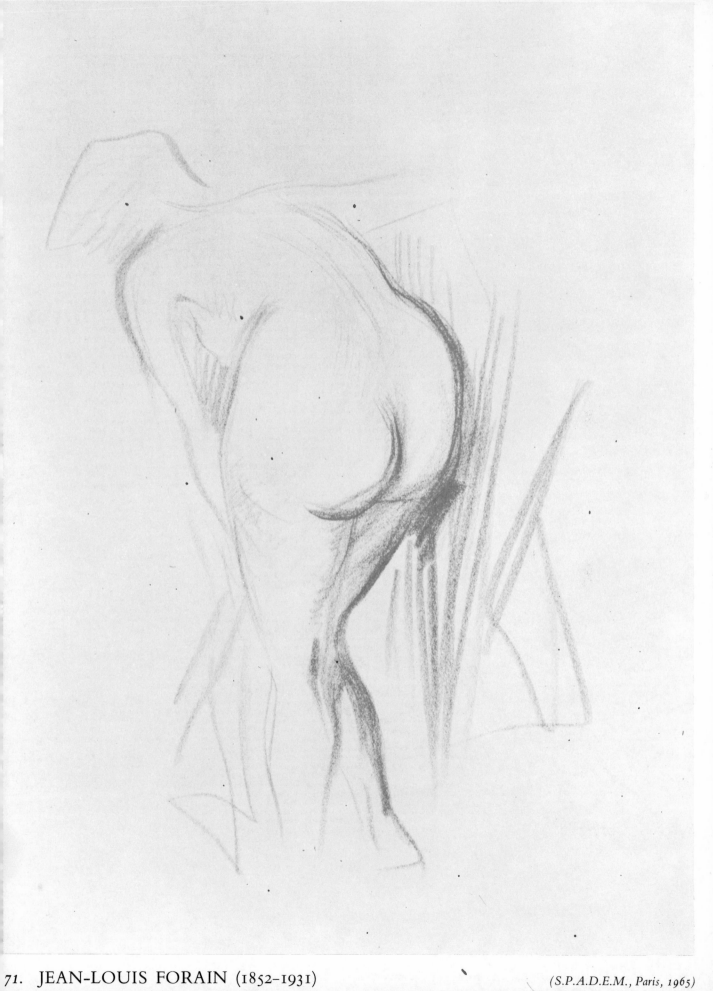

71. JEAN-LOUIS FORAIN (1852-1931) (S.P.A.D.E.M., Paris, 1965)

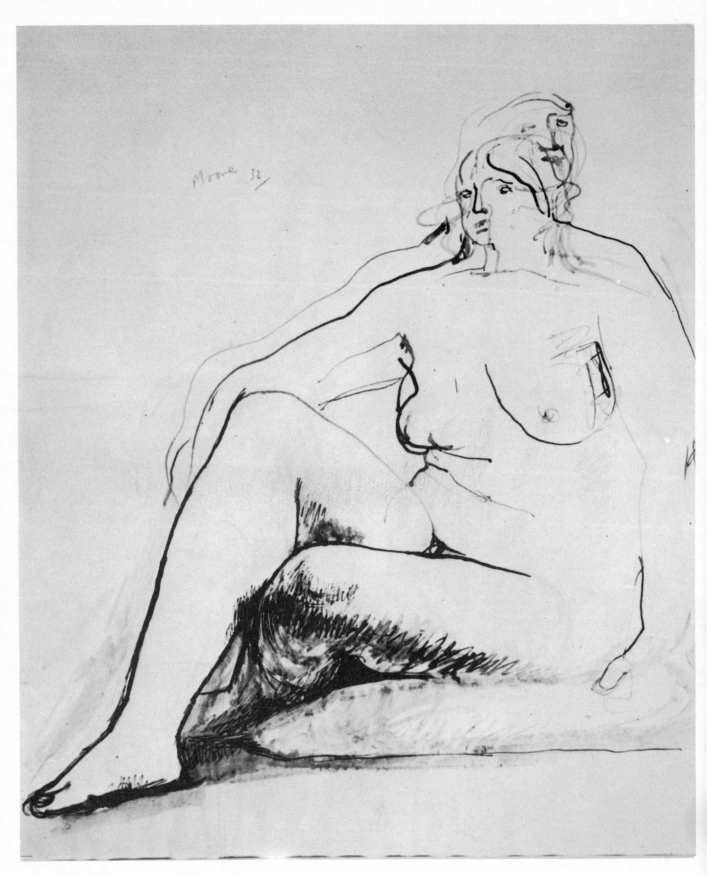

72. HENRY MOORE (1898–)

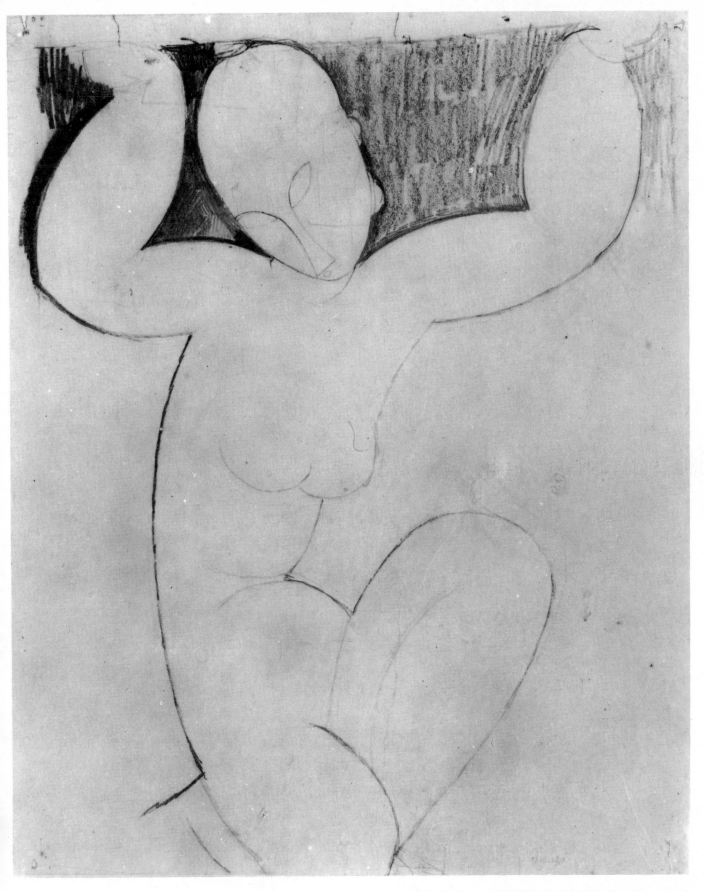

73. AMEDEO MODIGLIANI (1884-1920)

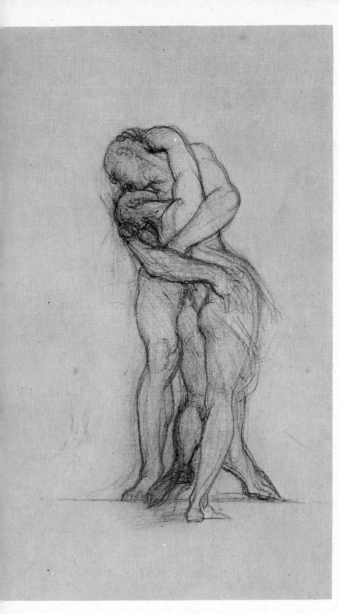

74. HENRY FUSELI (1741-1825)

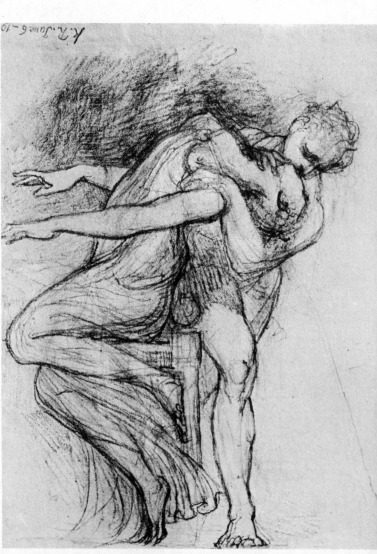

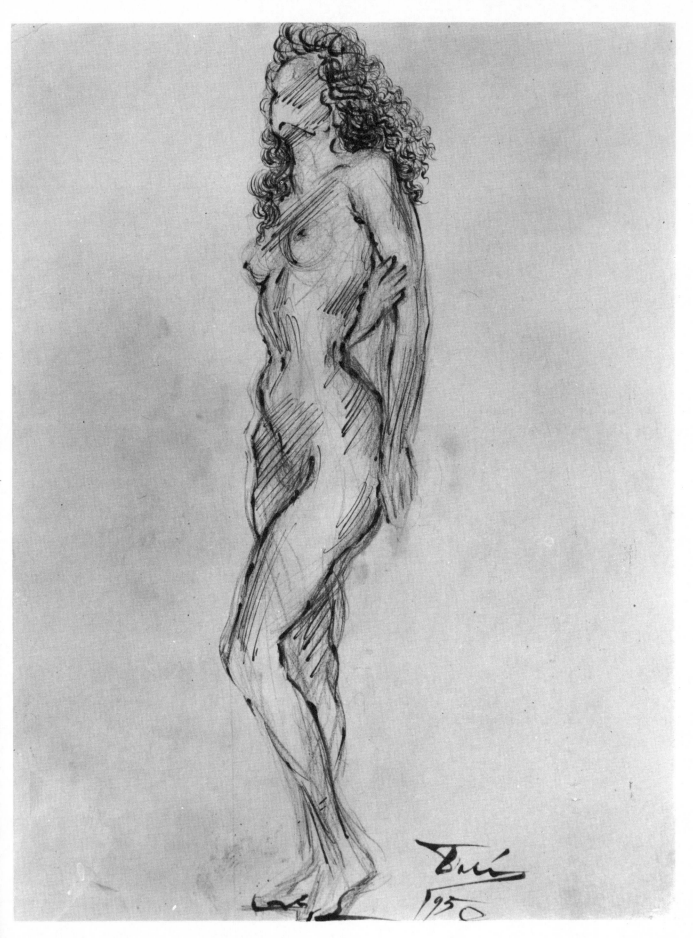

75. SALVADOR DALI (1904-) (S.P.A.D.E.M., Paris, 1965)

76. HENRI MATISSE (1869–1954)

(S.P.A.D.E.M., Paris, 1965)

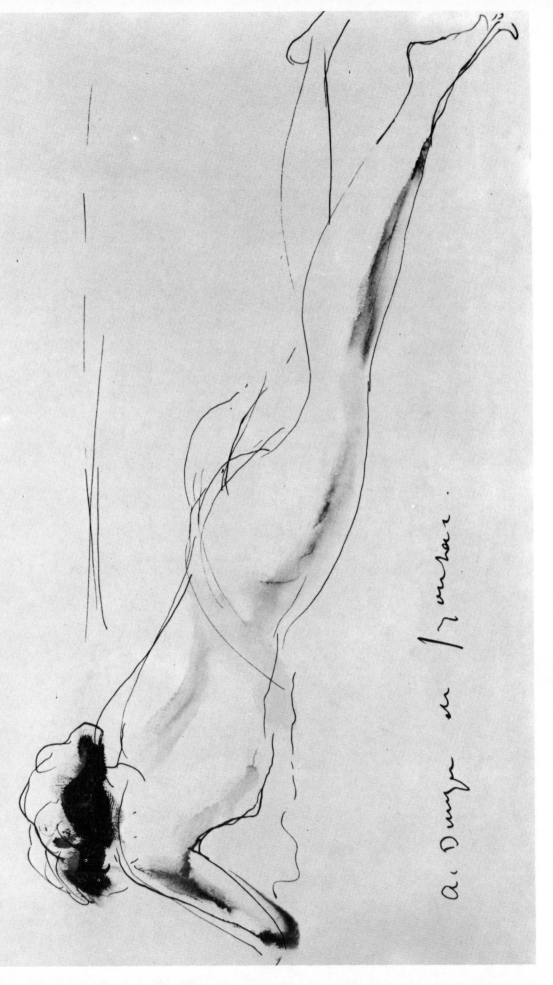

(S.P.A.D.E.M., Paris, 1965)

77. ANDRÉ DUNOYEN DE SEGONZAC (1884–)

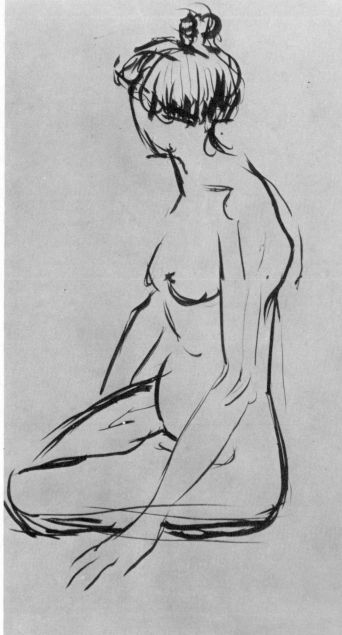

78. ALBERT MARQUET (1875–1947)

(Rights reserved A.D.A.G.P.)

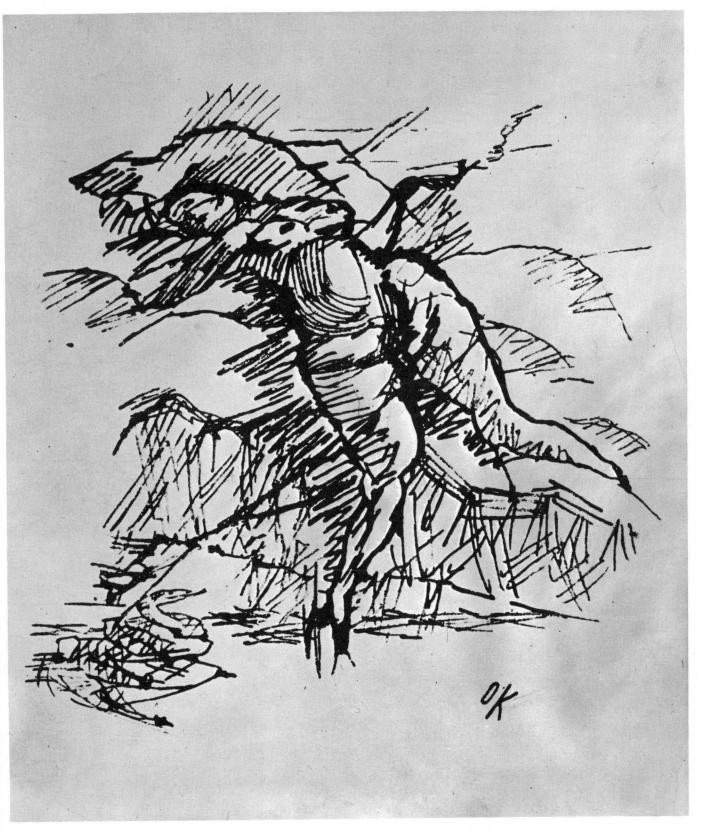

79. OSKAR KOKOSCHKA (1886–)

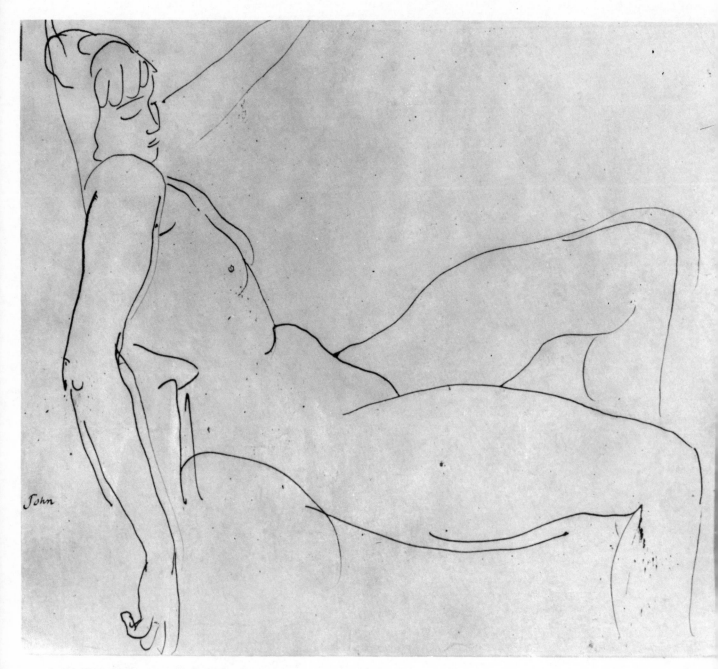

80. AUGUSTUS JOHN (1878–1961)

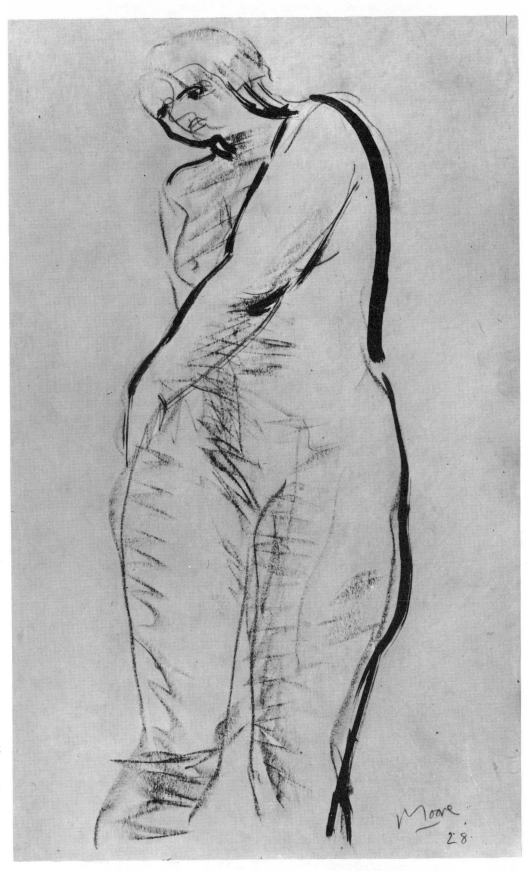

81. HENRY MOORE (1898–)

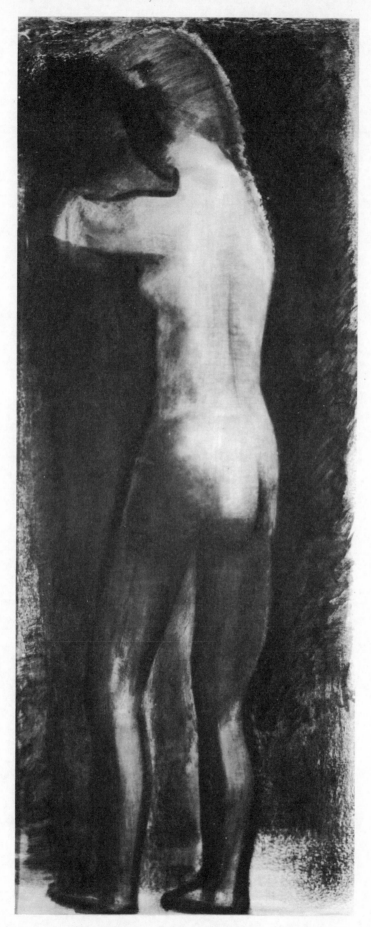

82. CONSTANT PERMEKE (1886–1954)

(© SABAM, Brussels)

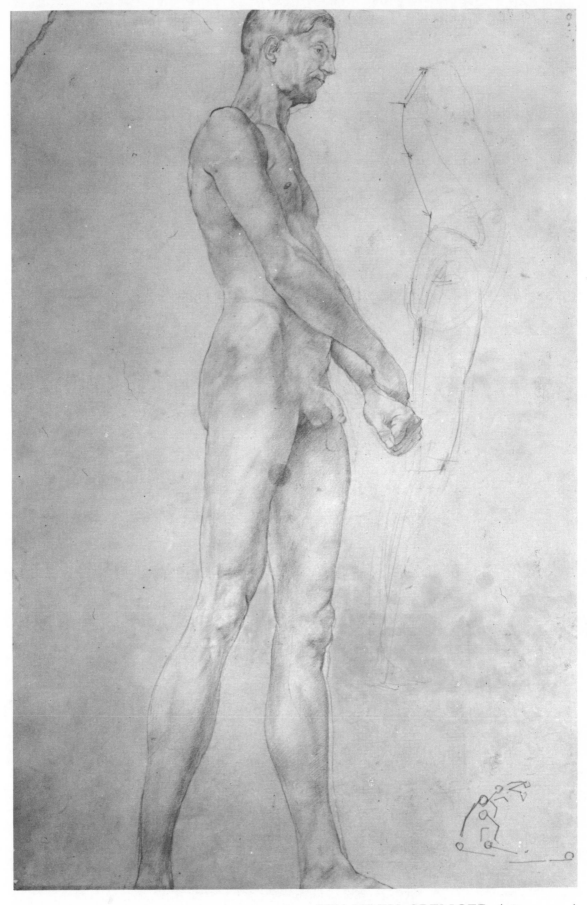

83. STANLEY SPENCER (1891-1959)

84. EMILIO GRECO (1913-)

WILLIAM SCOTT (1913-)

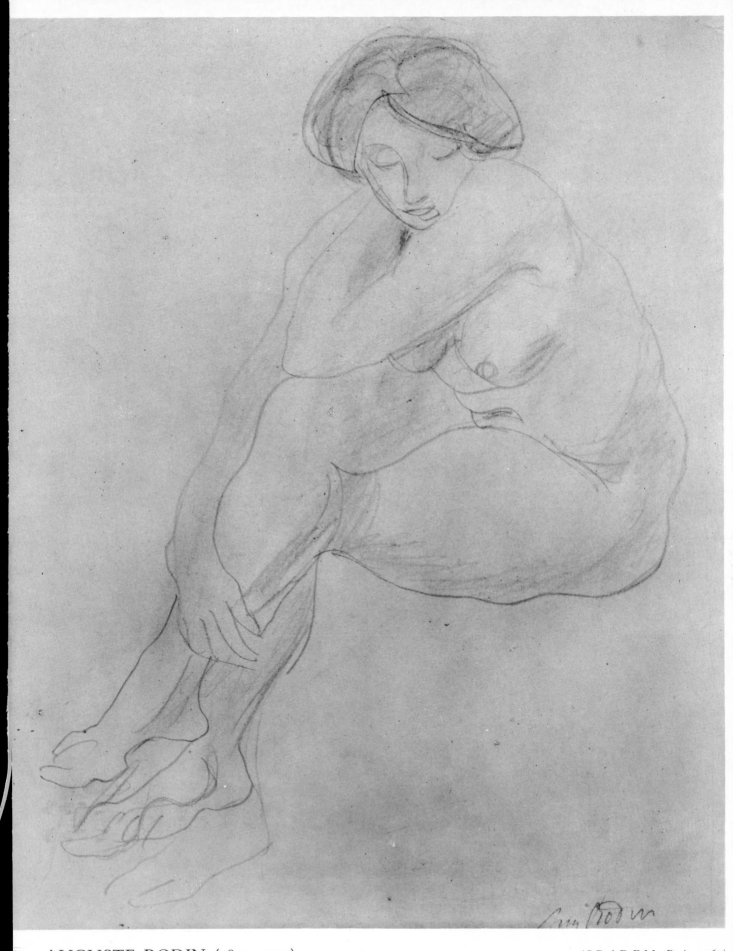

85. AUGUSTE RODIN (1840–1917)

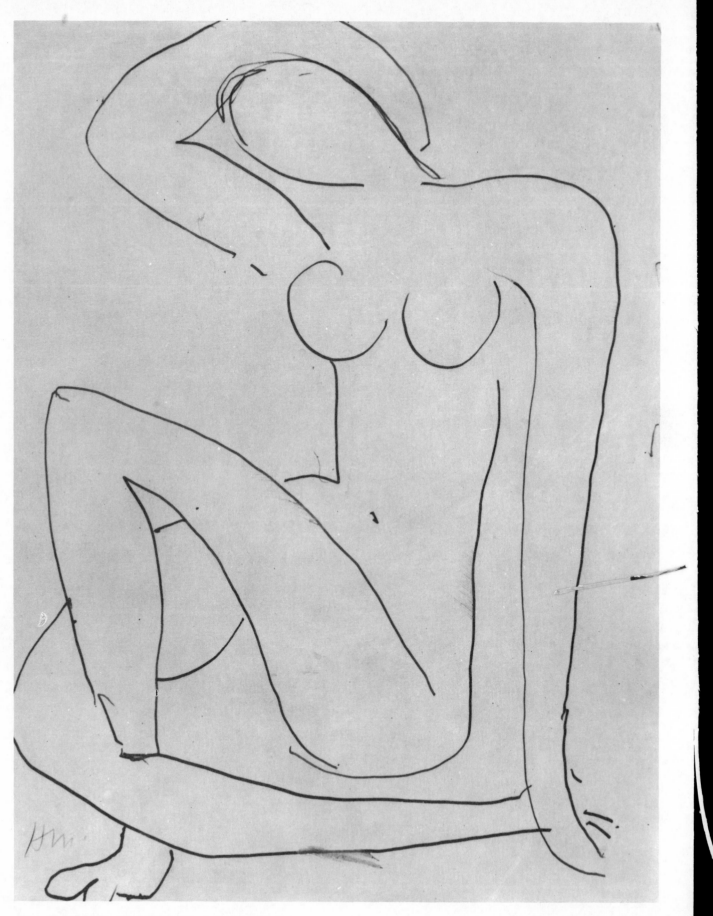

86. HENRI MATISSE (1869–1954) (*S.P.A.D.E.M., Paris, 1965*)

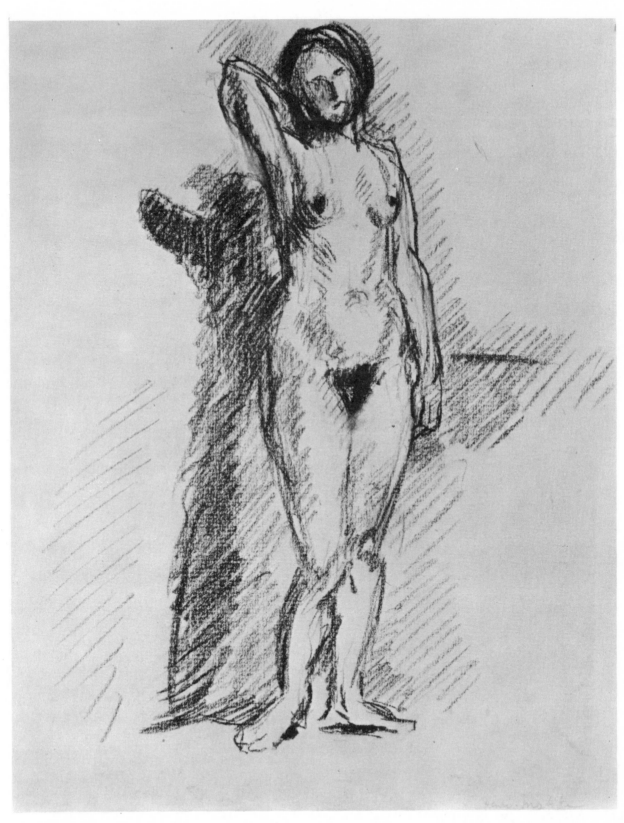

87. HENRI MATISSE (1869–1954) (S.P.A.D.E.M., Paris, 1965)

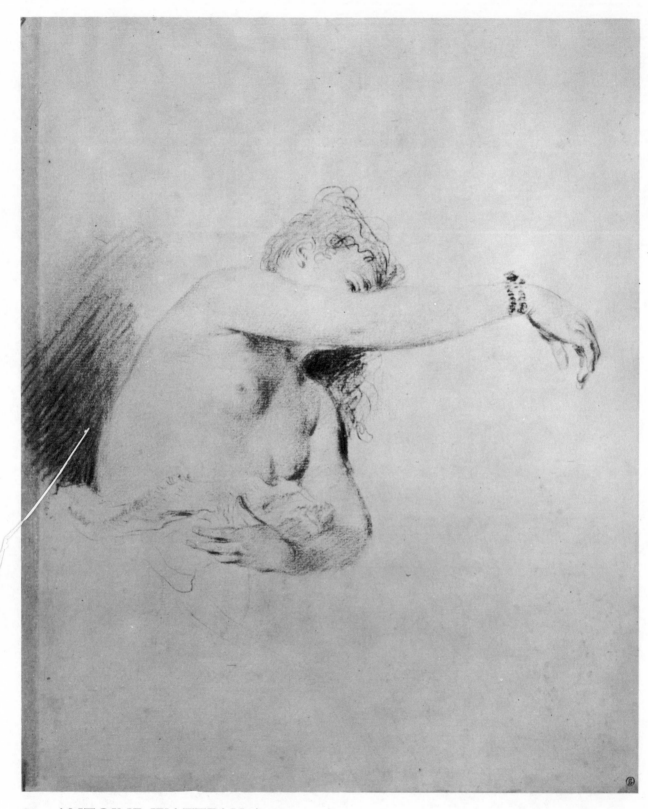

88. ANTOINE WATTEAU (1684–1721)

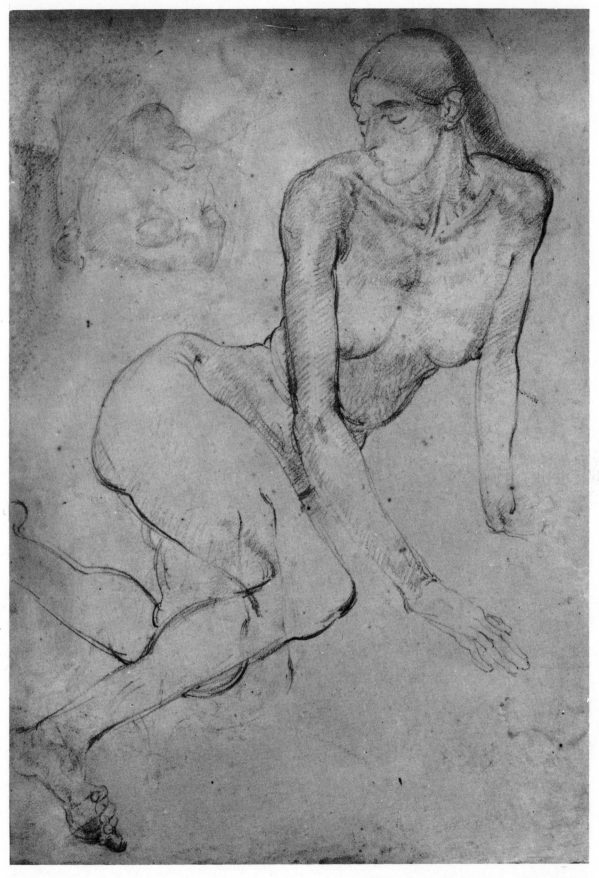

89. JACOB EPSTEIN (1880–1959)

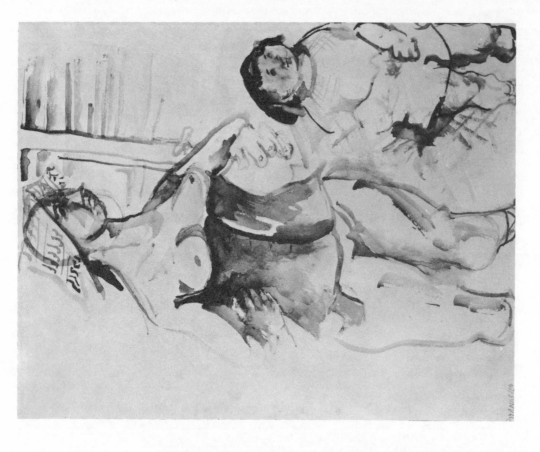

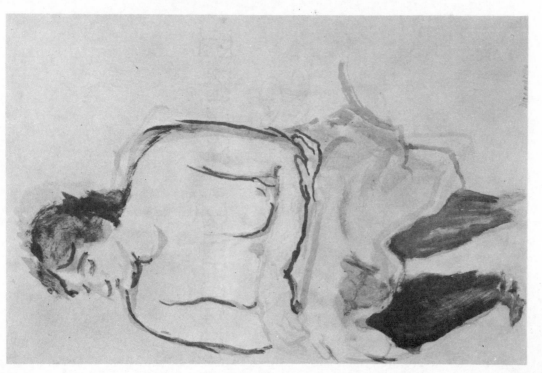

90. FAUSTO PIRONDELLO (1889–)

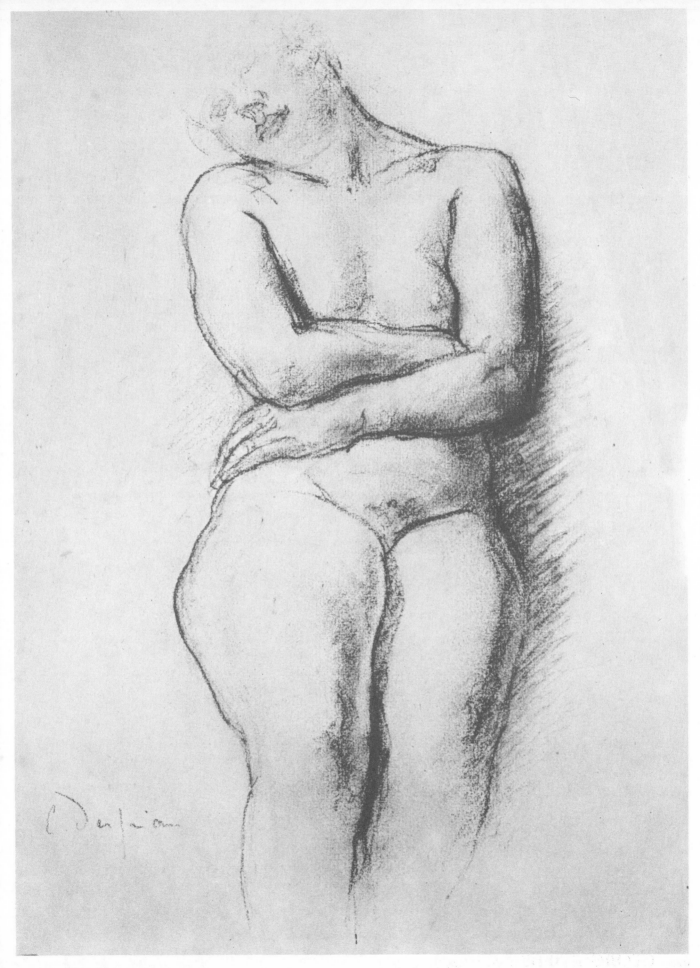

91. CHARLES DESPIAU (1874–1946)

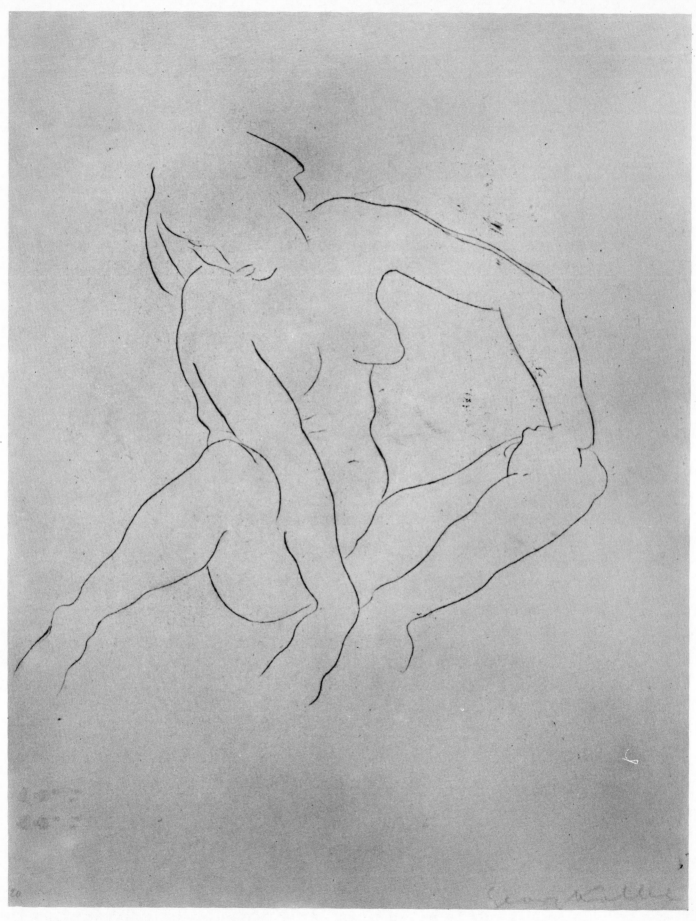

92. GEORG KOLBE (1877–1947)

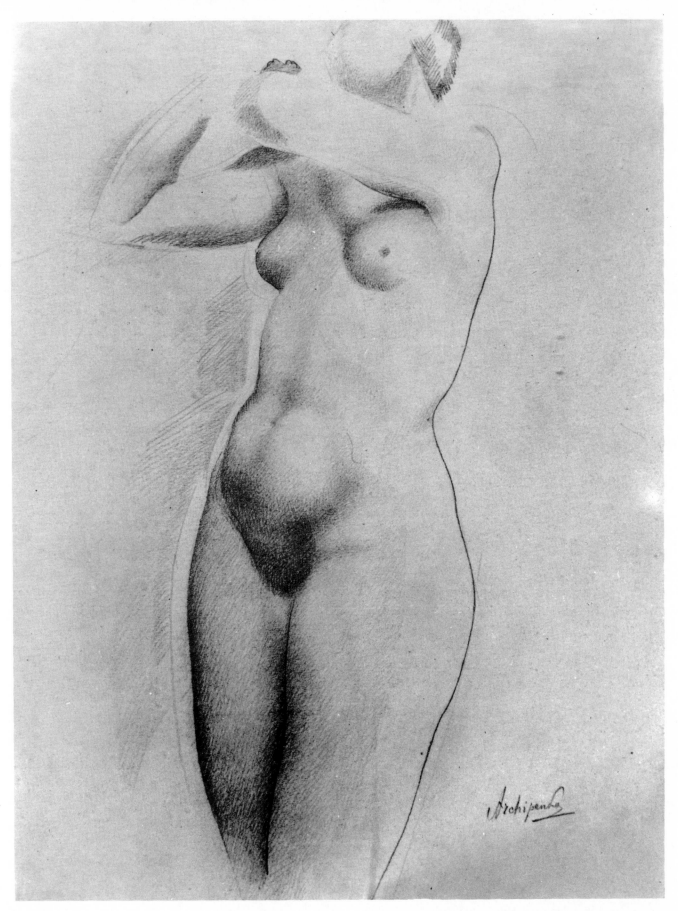

93. ALEXANDER ARCHIPENKO (1887–)

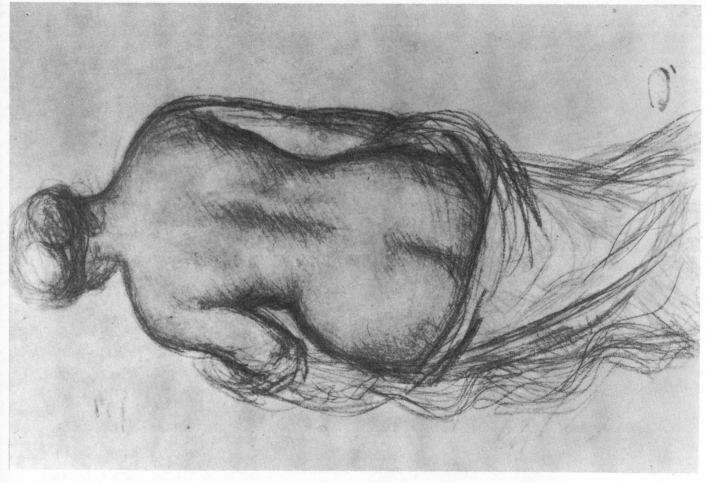

94. OTTO DIX (1891–)

ARISTIDE MAILLOL (1861–1944)

(*S.P.A.D.E.M., Paris, 1965*)

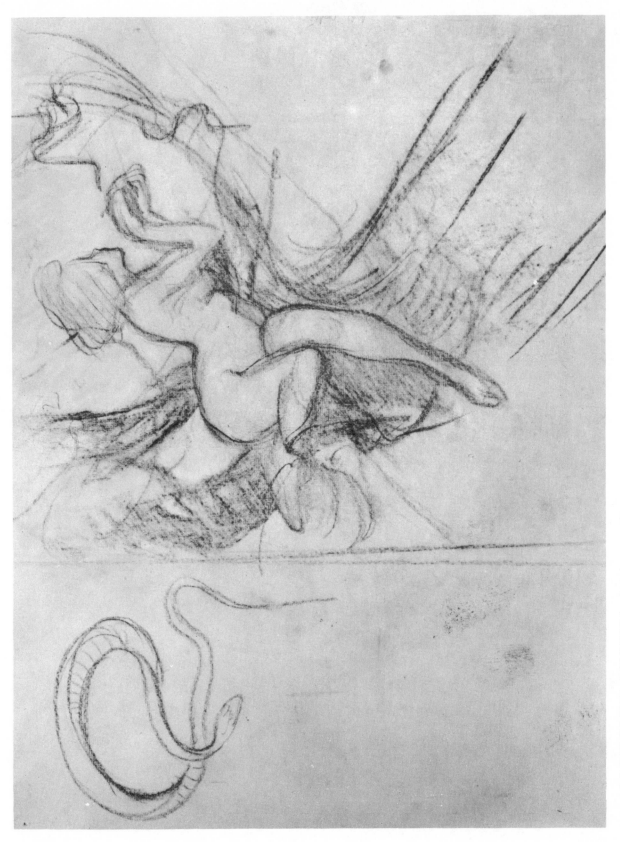

95. ALPHONSE MUCHA (1860–1939)

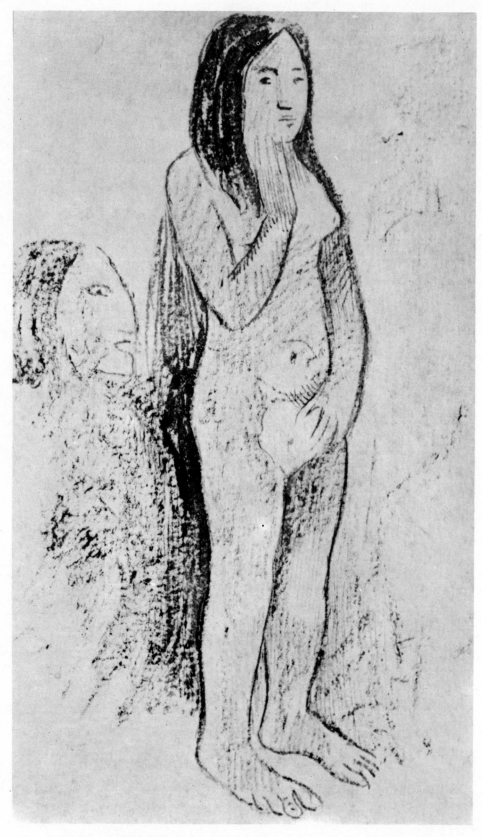

96. PAUL GAUGIN (1848-1903) (S.P.A.D.E.M., Paris, 1965)

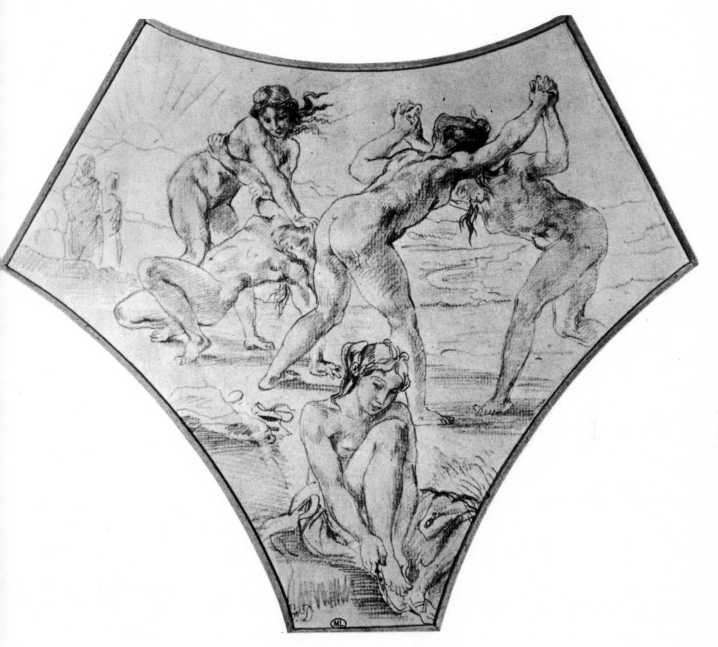

97. EUGENE DELACROIX (1798–1863)

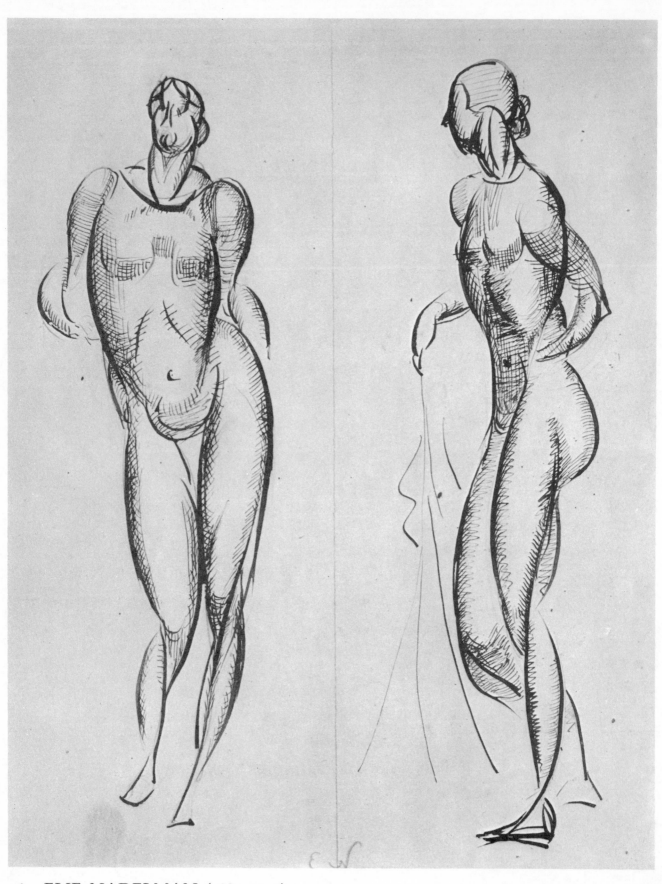

98. ELIE NADELMAN (1885–1946)

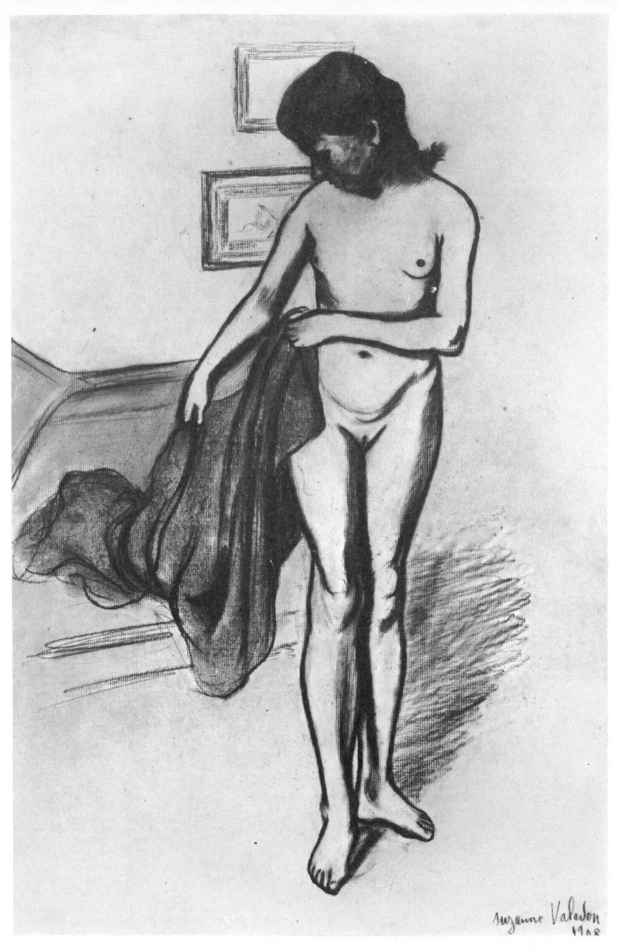

99. SUZANNE VALADON (1865–1938)　　　　　(*S.P.A.D.E.M., Paris, 1965*)

Souza 1962

100. F. N. SOUZA (1924–)

Souza 62

101. ALPHONSE MUCHA (1860–1939)

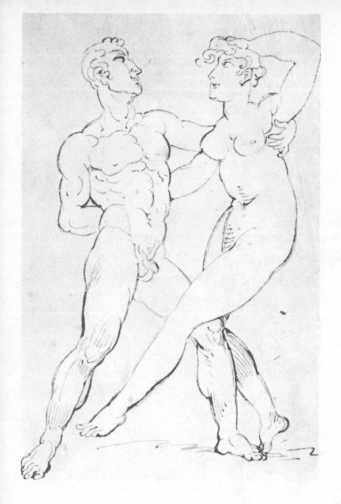

102. THOMAS ROWLANDSON (1756–1827)

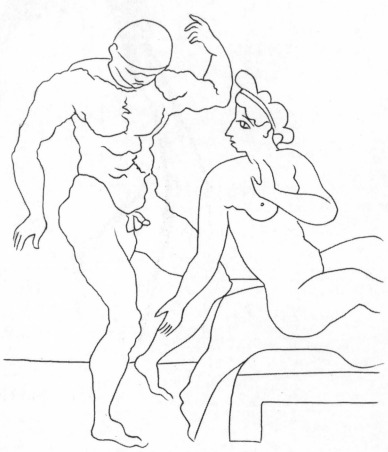

ANDRE DERAIN (1880–1954)

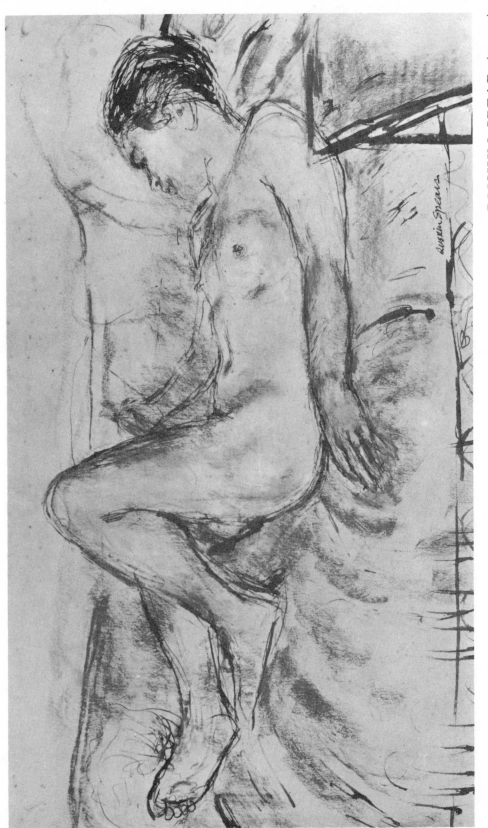

103. RUSKIN SPEAR (1911-)

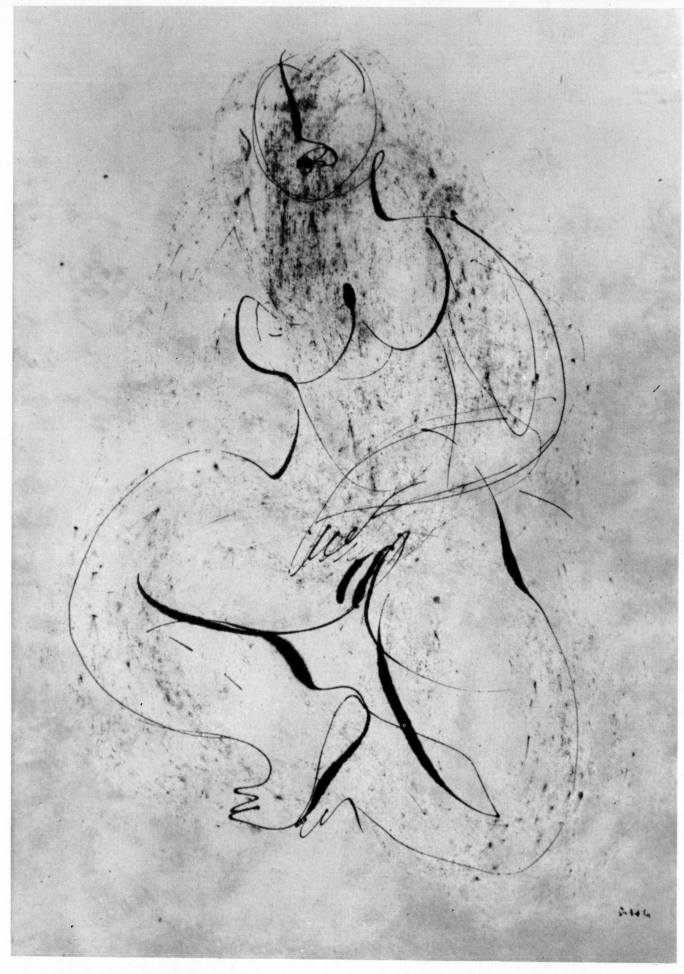

104. JEAN FAUTRIER (1897–) (S.P.A.D.E.M., Paris, 1965)

105. HORACE BRODZKY (1885–)

106. OSKAR KOKOSCHKA (1886–)

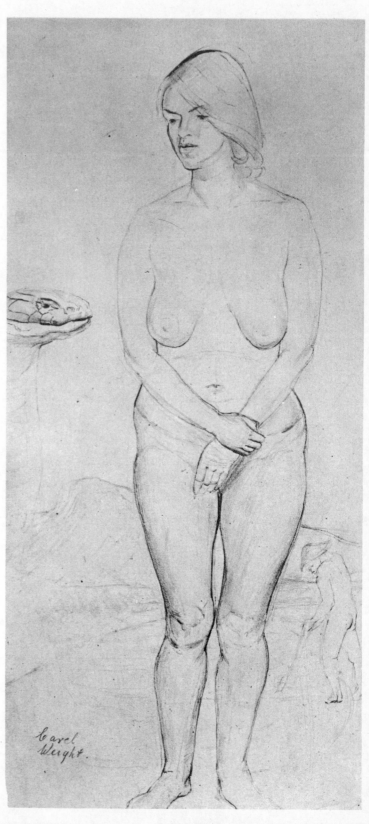

CAREL WEIGHT (1908–)

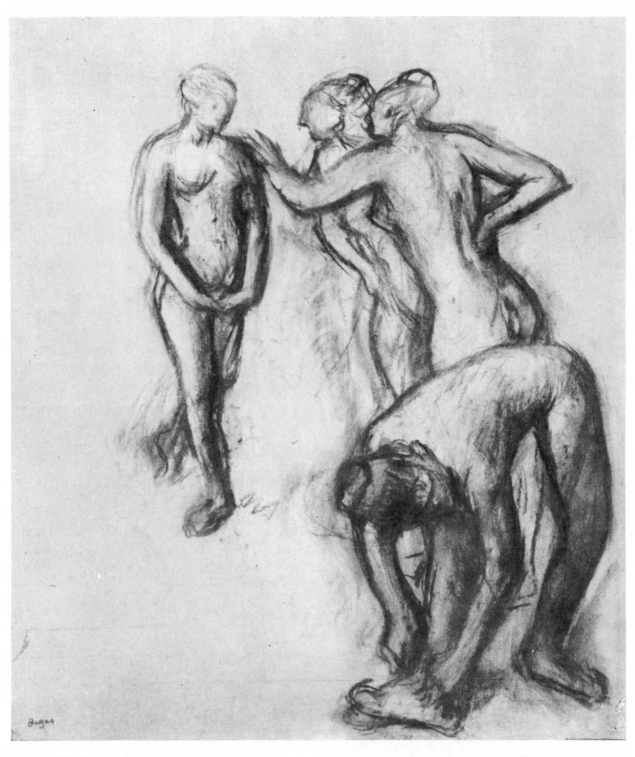

107. EDGAR DEGAS (1834–1917) *(S.P.A.D.E.M., Paris, 1965)*

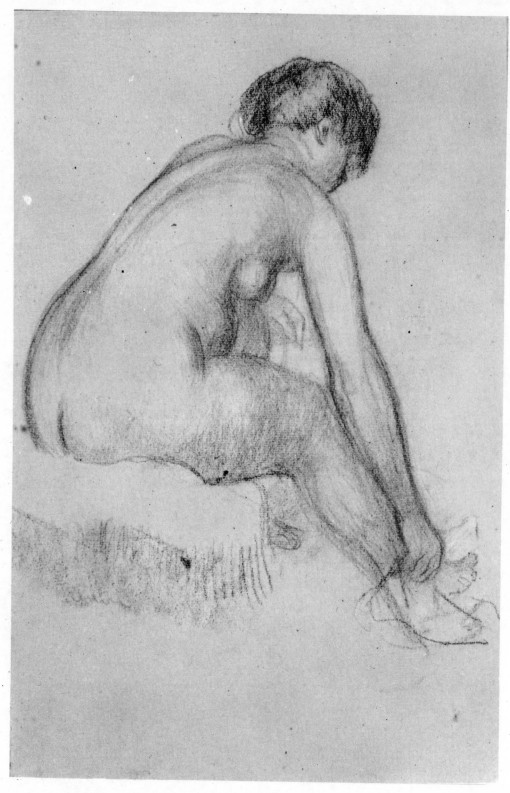

108. PIERRE-AUGUSTE RENOIR (1841-1919)

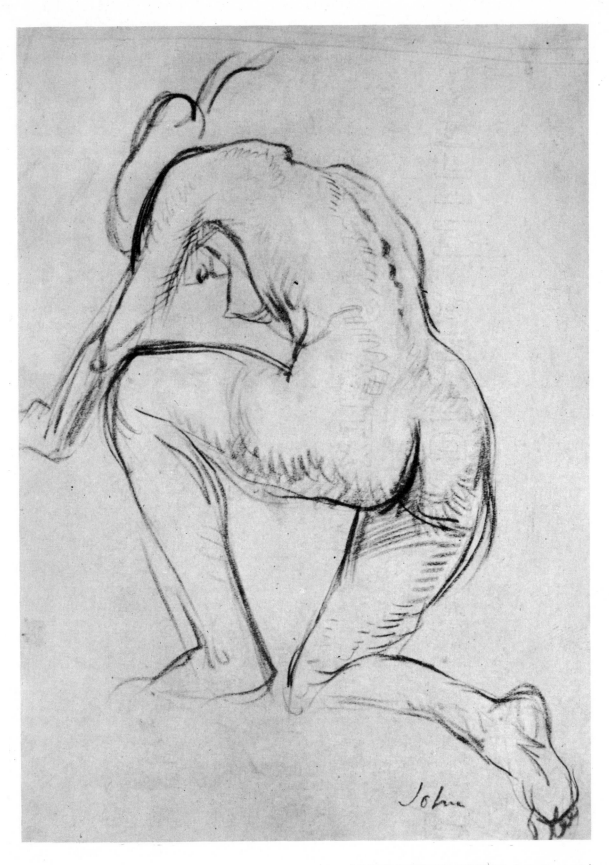

109. AUGUSTUS JOHN· (1878–1961)

110. GASTON LACHAISE (1882–1935)

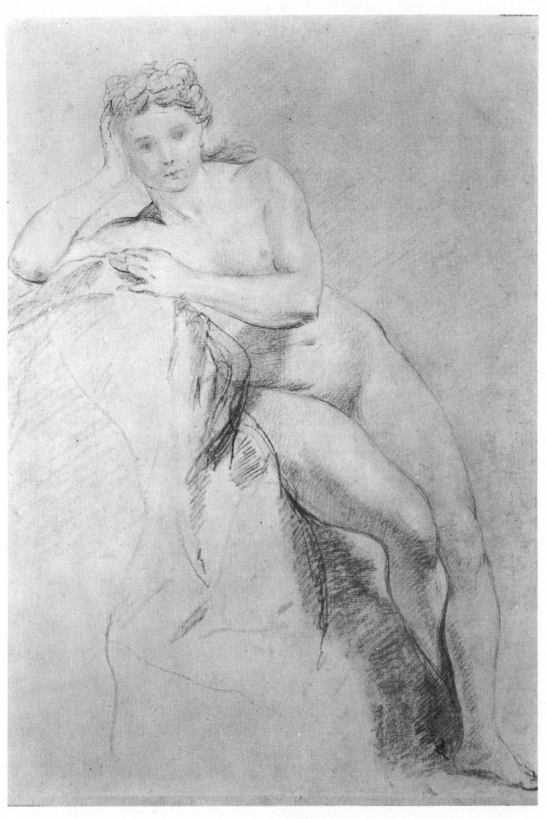

111. JOSHUA REYNOLDS (1723–92)

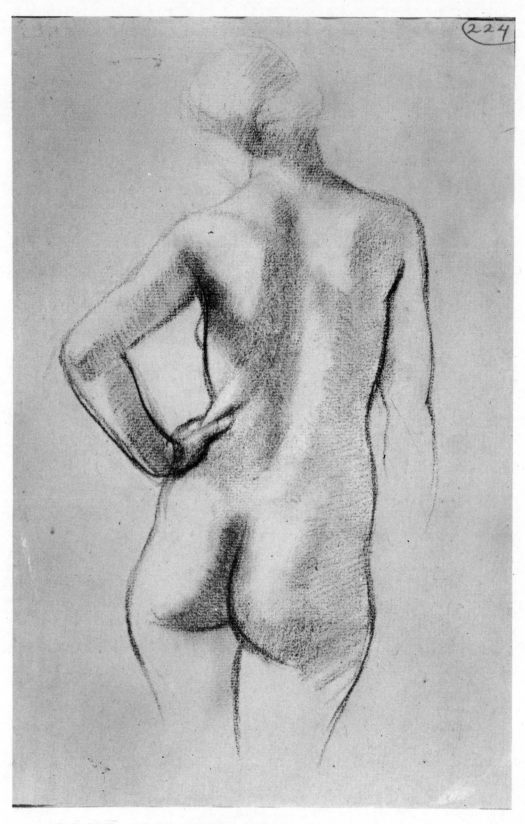

224

112. ROGER DE LA FRESNAYE (1885–1925)

(S.P.A.D.E.M., Paris, 1965)